RIJKS MUSEUM

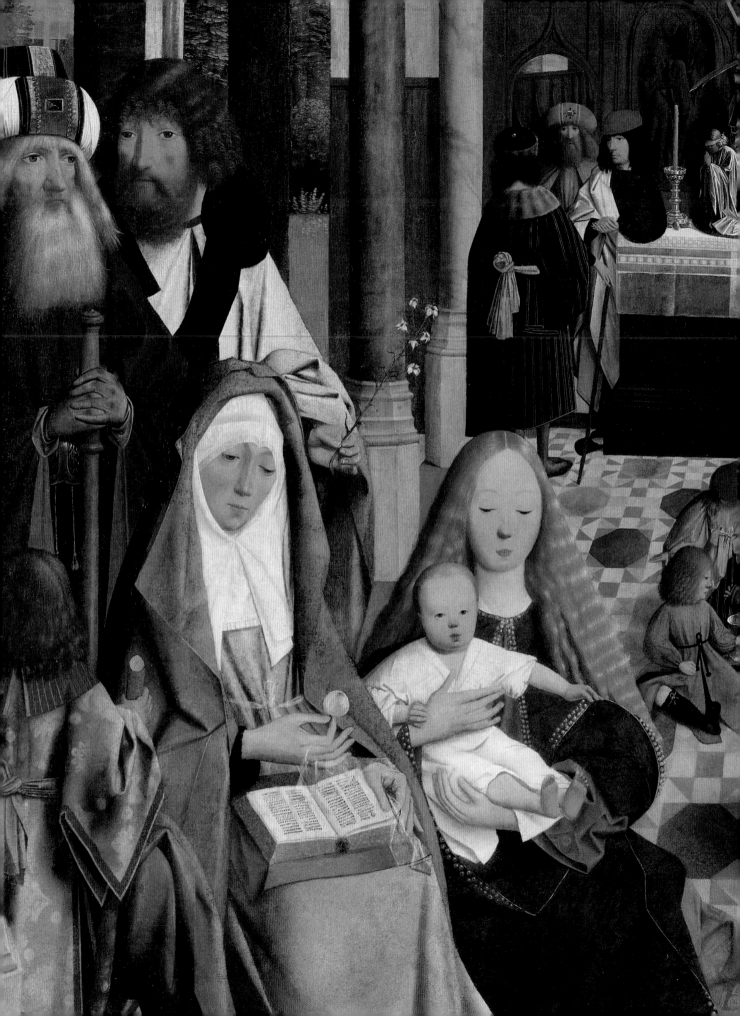

RIJKS MUSEUM

The Building,
the Collection and
the Outdoor Gallery

Amsterdam
University
Press

Cees W. de Jong & Patrick Spijkerman

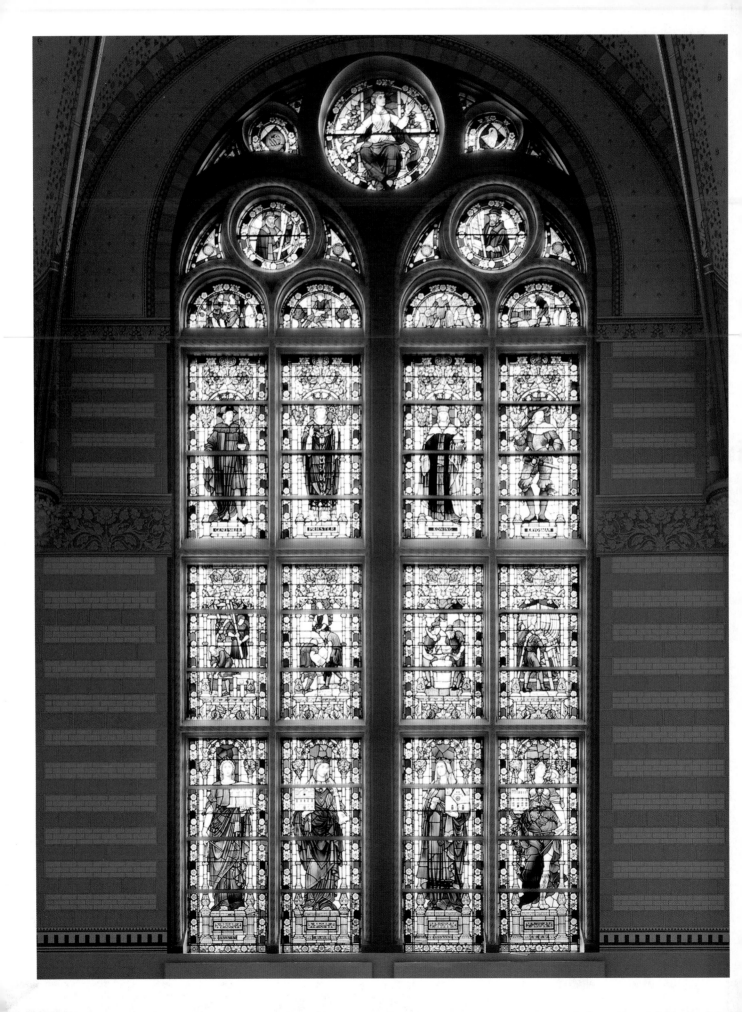

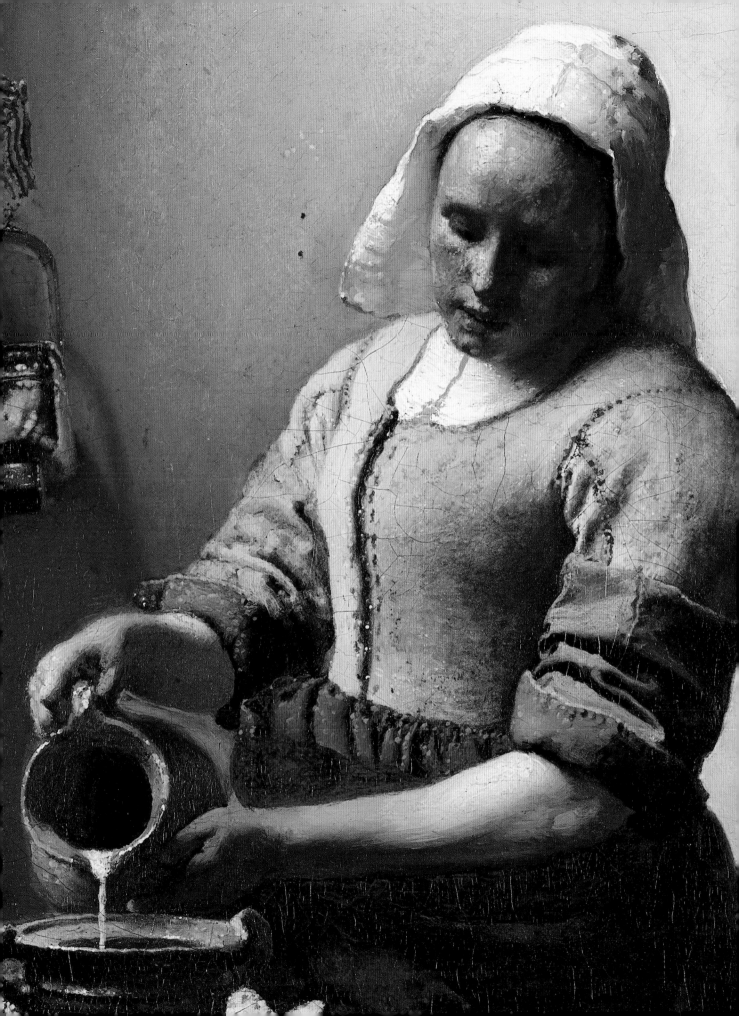

ISBN 978 90 8964 900 3
NUR 648

Contents

Restored to future glory

'Colour and taste should not compete' is a quote taken from Polychromie architecturale (Polychrome architecture)* by architect and painter Le Corbusier. This previously unpublished text first appeared in the catalogue *Kleur en architectuur* (*Colour and architecture*) during an exhibition held at the Boijmans van Beuningen Museum and the Groninger Museum. I visited it at the latter. At that time, the incomparable Frans Haks, former director of the Groninger Museum, had been overseeing plans for a spectacular new project – the construction of a new museum in the water. This postmodern concept was under the supervision of the dynamic Italian designer Alessandro Mendini with additional contributions from Philippe Starck and Coop Himmelblau. With its choice of laminate, Bisazza mosaic tiles and wildly decorative epoxy resin flooring, Groningen emerged as the city with the most colourful museum in the world. The artist Peter Struycken created a colour palette for the interior walls of the museum. The intense, crackling neon work of art from François Morellet in the entrance hall and Swip Stolk's exuberant graphic design complemented the overall effect.

I was a great admirer of Haks at the time – there, in Groningen, something happened the likes of which had never before been seen. This appreciation hasn't waned over the years because numerous exhibitions later – and I've seen quite a few – the museum still looks as fresh and vibrant as the day it first opened. I was treated to a visual delight. Expressionist painters from De Ploeg (The Plough) were highlighted in bright red and fuchsia, Ilya Repin in aubergine and Azzedine Alaia in sky blue. Anything was possible and it all came together flawlessly. Frans Haks' incredible magic box still hasn't reached its limit. And each time, you leave with a smile on your face. That's the power of colour. Colour only becomes evident when you see it is a description that could easily be attributed to some typically unfathomable Johann Cruijff logic. Yet despite the fact that everything has colour, you're seldom aware of most of the colours around you. Even in a museum, where a heightened sense of visual perception is expected, not every colour will be detectable. That is why Haks' Groninger Museum is so enjoyable. He completely immerses the visitor in a vortex of colour.

A hundred years before Haks, architect Pierre Cuypers achieved roughly the same goal with 'his' Rijksmuseum. Cuypers doesn't allow the eye a moment's rest in this neo-Gothic *Gesamtkunstwerk* (*Universal artwork*). Bright stained-glass windows, terrazzo floors, intricately carved stone, wood and metal ornaments; everywhere, a bombardment of visual stimuli. Cuypers especially used colour and ornament to reinforce his agenda. His Rijksmuseum is an homage to Dutch patriotic art and history, an equally credible as surprising concept in which everything has a place and there is no room for aberrant behaviour. Cuypers was devoutly religious, which in turn influenced the use of colour. Colours are present in the same way they are in Groningen, but Amsterdam misses Haks' frivolity.

In 2013 the Rijksmuseum opened, courtesy of Cruz y Ortiz Arquitectos, 'restored to future glory'. Under the motto 'Continue with Cuypers' the main aim has been to return the building to its original condition. The exterior façade has been magnificently renovated, the inner courtyards have been re-established, incorporated floors have been demolished and the original skylights have been reinstated. The monumental stairwells, library and majestic Grand Hall have all been fully restored and redecorated with original ornamental elements including paintings by Georg Sturm, which were removed at the start of the twentieth century. In short, Cuypers fans can indulge themselves to their heart's content. At the same time the building has been prepared for today's and tomorrow's visitor who expects a contemporary museological scenography, while also complying with current safety- and environmental regulations. The collections in the Rijksmuseum are diversely showcased over more than 80 rooms – from the Middle Ages to Mondriaan. Where various areas were once divided into sections – glass, painting, furniture, historical objet d'art, weapons, Delftware etc - this new arrangement allows the story of the Netherlands to unfold in chronological order,

Work meeting held between Antonio Ortiz
and Antonio Cruz, Cruz y Ortiz Arquitectos,
Seville. The architects were responsible for the
renovation and the restoration under the motto
'Continue with Cuypers'.

and art and history to parallel each other. In this three-dimensional timeline, the rooms on each floor are painted with new colours courtesy of the French architect Jean-Michel Wilmotte. His interior colour palette complements Frans Haks' philosophy: colour in the service of art.
The visitor will encounter a colour on every floor, in every century, which repeatedly refocuses the eyes. Wilmotte's colour palette is aligned with that of Cuypers, which, because of the monochrome application and the lack of ornaments, forms a complementary contrast.
In addition to Cuypers' original colours – restored largely by restoration atelier SRAL under supervision of Anne van Grevenstein– the colours for the new spaces were determined, in consultation with Wilmotte, by the principal Spanish architects Cruz y Ortiz Arquitectos. Natural materials, glass and travertine, have been chosen for the new atrium, left and right of the passage, the many corridors, stairs, lifts, toilets, the auditorium and the new museum shop.
One colour dominates the areas which were painted: white RAL 9010. This rewarding 'no-quibble-colour' is now considered a museum colour par excellence. During my years at the Kunsthal Rotterdam, RAL 9010 was the standard.
The renovated Stedelijk Museum boasts the same white, which incidentally seems slightly warmer than the famous white with which Sandberg once whitewashed the colourful brick walls. White has however now been 'banished' to the non-museological spaces in the new Rijksmuseum. Because of the recent renovation and redesign, Cuypers' nineteenth century colour palette has been restored. We recognise twentieth century modernism in non-museological spaces and the exhibition rooms have been decorated 'à la mode française'. And so it goes that the new Rijksmuseum anno 2013 is restored to its future glory.

Wim Pijbes,
General-Director Rijksmuseum

*) *Kleur en architectuur* (*Colour and architecture*), exposition catalogue
Boijmans van Beuningen Museum, Rotterdam and Groninger Museum, 1986

Well-known cartoon from J.P. Holswilder, from
De Lantaarn dated July 15th 1885, where Pierre
Cuypers together with sympathisers Joseph
Alberdingk Thijm and Victor de Stuers kneel
in front of the Rijksmuseum during its inves-
titure as the Dutch temple of nationalistic art
(Collection Cuypers House Museum Roermond).

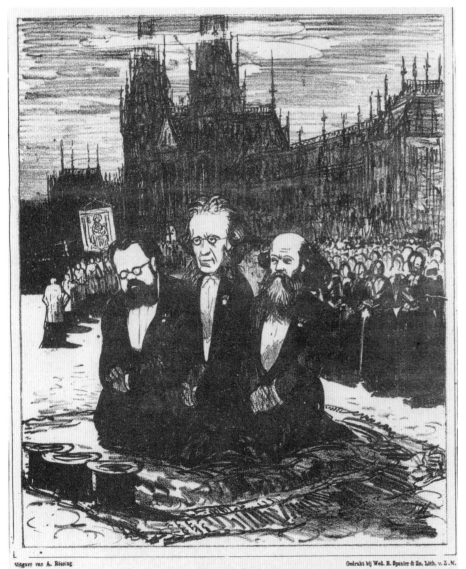

Uitgave van A. Rössing. Gedrukt bij Wed. E. Spanier & Zn. Lith. v. Z. M.

Wijding van het Bisschoppelijk Paleis, genaamd ,,het Rijksmuseum te Amsterdam.''

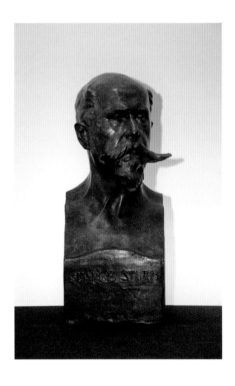

Commemorative medal bearing the portrait of
Pierre Cuypers, born in Roermond May 16th
1827, (Collection Cuypers House Museum
Roermond).

Bronze bust of Georg Sturm fashioned in 1918
by August Falise, (Collection Cuypers House
Museum Roermond).

Consummate experience

It has been claimed that some cave paintings in the Spanish region of Nerja are 42,000 years old. That is extraordinary because that would make the artist a Neanderthal. Artistic ability has long been seen as a quality typical of modern man, the *homo sapien*.

Throughout history man has felt the need to incorporate colour and form in his interiors. Sometimes there is mention of extreme sobriety, for example in a Benedictine cell or a modern, sterile interior. Man has often surrounded himself with exhibits, such as the frescos typical in Roman villas of the time or the awe-inspiring ornamental murals found on church walls. Unfortunately in the Netherlands, with its Calvinist heritage, the majority of the latter disappeared under layers of whitewash.

The realisation of the Rijksmuseum wasn't without its controversy. Victor de Stuers was one of the leading men of the time behind its conception. He was said to be an ultramontanist (advocating Papal superiority), wanting to convert the Netherlands back to Roman Catholicism by means fair or foul. In a well-known cartoon he is seen, together with sympathisers Joseph Alberdingk Thijm and Pierre Cuypers, kneeling in front of the Rijksmuseum during its investiture as the Dutch temple of nationalistic art. It's true that the Rijksmuseum conforms architecturally and ornamentally to De Stuers' recommended government doctrine. Furthermore, with its neo-Renaissance towers, it brings to mind the then newly constructed neo-Gothic churches – and Cuypers, who designed the Rijksmuseum, and an unprecedented number of the churches too.

To call the Rijksmuseum ultramontanes is going a bit too far. Indeed, on the exterior as well as the interior, there is mention of – the sometimes effusive – ornaments like those found in neo-Gothic churches; here they don't glorify God, but 'Patriotic Art' of which the Rijksmuseum was, and still is, the Netherlands' most important shrine. Even the interior ornamental elements, which will be touched upon in this book, are an integral part of the neo-Renaissance architecture and should be treated as such.

Inextricably linked. That was the conclusion of everyone who deciphered *and* understood the architecture of the Rijksmuseum. However, the number of proponents quickly declined. In 1908, architect Adolf Loos declared ornamentation to be a crime. Worse still, museum directors were granted complete control. The building had to adapt to the exhibition. For a museum director the building is a mantle that shrouds the religious artefacts he cherishes: Art – with a capital A. The Rijksmuseum never became what Cuypers intended it to be. As soon as parts of the building were completed and museum directors began to take control, the whitewash brush came out, modifying the interior to modern tastes and the changing views on exhibiting. Even the new Rijksmuseum must comply with regulations associated with the collection and presentation of that which the building religiously cherishes: Art. Still, during the transition from the old to the new Rijksmuseum – principally a continuation of Cuypers – particular attention has been given to his architecture including the interior ornamental elements, which are inextricably connected. Especially if they formed an essential and indispensable part of the architectural structure, they were fully restored. Since the opening, a visit to the museum is much more complete and the experience far better than the present generation ever dreamed possible. Although this might take some getting used to for the modern museum-goer.

Frits van Dongen,
Chief Government Buildings Architect

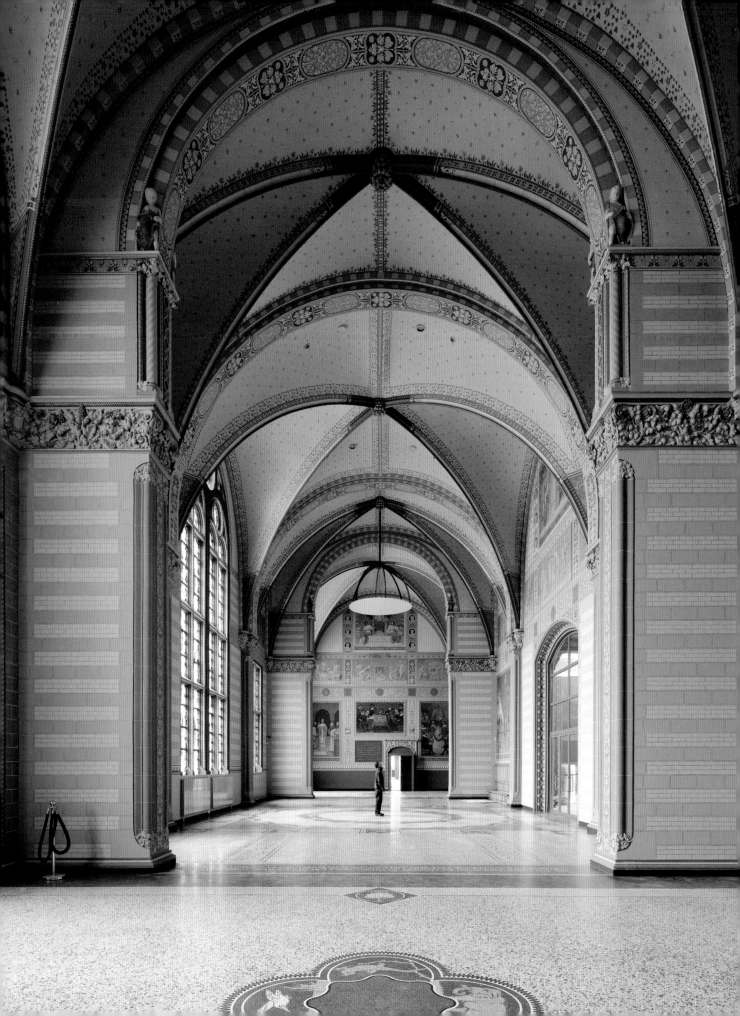

The building,
continue with Cuypers

Criteria for the renovation and restoration of the new Rijksmuseum.

The motto 'Continue with Cuypers' is not only about renovation, but also restoration. The latter may seem like a trivial addition, but is of great importance in order to accurately assess the historical and monumental aspects of this building.

A building, unlike a painting or composed piece of music, is not a completed piece of artwork. Buildings undergo countless changes during their lifespan. An architect starting work on an existing structure should take into account the history of these changes and use it as a source of knowledge and support during his decision making process. Cruz y Ortiz deliberately dismantled an important part of the twentieth century addition to take advantage of as much of Cuypers' original spatial concept as possible. However, the building's original condition shouldn't be the only determining factor.

The building's renewed purpose differs strongly from its initial objective at the time of its completion in 1885. Visitor numbers have grown and the museum adheres to a very different set of requirements, which necessitate space. At the same time, new technical demands apply to some contemporary facilities.

Moreover, the concept of the museum, its collection and the manner in which the collection is exhibited has changed. As an already existing structure, the Rijksmuseum is unable to comply with every single new regulation. The project, however, has been modified as much as possible in order to satisfy today's exhibition concept with regard to climatic conditions and quality of the exhibition spaces.

The building shouldn't be regarded as a series of decisions resulting from various architectural, monumental or museum-biased contributions, but as an independent work of art that combines and integrates the various elements.

The building: the basic structure

Cuypers' building served two purposes: it housed the National Museum - the symbol of the flourishing nationalism - and formed the entrance to the then upcoming southward expansion of Amsterdam.

The major problem from a topological point of view was that a municipal passage had to be created underneath the structure of the uniform building. Using the north-south symmetry axis as its central reference to connect the existing city of Amsterdam to the impending expansion to the south, a standard blueprint for a building with two courtyards was chosen. For this reason, the underpass - which would not only take up space on the ground floor, but also on the intermediate floors, and which was orientated towards the aforementioned symmetry axis - required that the entrance and the main staircase of the building be repositioned. Every feature would have to be doubled and symmetrically placed on either side of the passage. From a formal and functional perspective the underpass would become the most important feature of the building, distinguishing it from the other symmetrically designed buildings of the late nineteenth century.

When the problem of the double entrance and the two staircases were finally resolved, Cuypers constructed the three-floor building plan in a symmetrical and methodical way. He started with a grid of approximately 5x5m. This formed the basis for the eventual ground floor and arches. Several central pillars were removed from the intermediate floor to create larger spaces. Almost all the columns were removed from the main floor and the original grid was replaced by large adjoining spaces, only divided by the walls of the façade. The 5x5m grid gave the building a structure that is recognisable in both the composition as well as in the design of the façade. The grid and the basic geometric design has proven to be advantageous over the course of time and, even after various alterations, has helped retain the building's uniformity.

This is emphasised in the now realised draft proposal. The inner courtyards have been uncovered and properly restored, as well as the northern and southern symmetry axis and the building's original clarity. The dimensions of the spaces and arches are reinstated according to Cuypers' original design. Moreover, the sense of structure and dynamics created by the inner courtyards is visible once more. Slight changes were made around the towers to accommodate for the installation of visitors' lifts and new fire escapes. Whilst symmetry and the grid had been decisive for the north-, east- and west façades, Cuypers chose another style for the south façade. Through localising the library he created a quaint symmetry between the library and the Villa (the administrator's house). Because of a difference in dimensions they don't strictly adhere to Cuypers' originally defined rules of symmetry. In this regard, the Rijksmuseum also reflects the Late Romantic ideals of its architect.

This was the beginning of a more artistic approach to the Rijksmuseum's south façade, which culminated in the design of the Fragmentengebouw (Fragments Building). Later, the Teekenschool (literally: Drawing School) was housed here. Of course, the south façade differs radically from the north façade, which adheres to a stricter symmetrical code. The north façade was previously considered the most important side of the building because it overlooked the city of Amsterdam. Proof of this is depicted in the drawings that Cuypers submitted to the design contest for the Rijksmuseum, all of which singularly portray the north façade.

This vivid process was initiated by Cuypers in the design of the library and the Villa and continued in the design of the Teekenschool. His son incorporated this design style with the Fragmentengebouw and the Vermeer-uitbreiding (Vermeer extension). This process formed the key to finding the right exhibition space to use during the renovation.

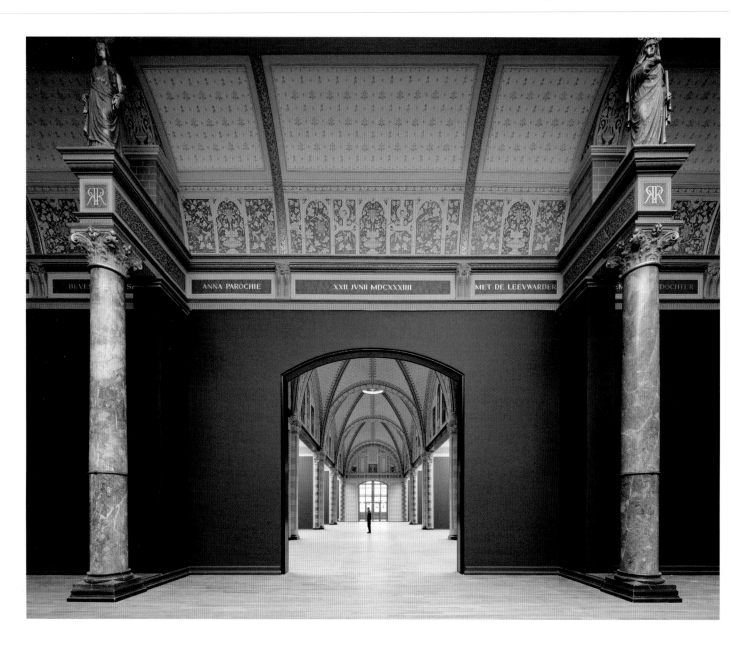

The Rijksmuseum houses an interesting collection of Asiatic art. This collection is housed in a pavilion, which is located between the main building and the Philips Wing. This particular site at the Rijksmuseum has been used for varying purposes over the years. The second new construction is a smaller extension, another pavilion, situated between the Villa and the Teekenschool and located on a site that initially housed a garage: The Entrance is used for several purposes – as a delivery access to the main building and as a staff and visitors' entrance to the Teekenschool. The connection to the Teekenschool is created on the first floor and in turn, the Teekenschool is connected to the main building through the basement.

The ceremonial function of the Gallery of Honour is almost identical to that of a hundred years before.

The uniformity of the ornaments follows and emphasises the construction of load-bearing elements in the architecture.

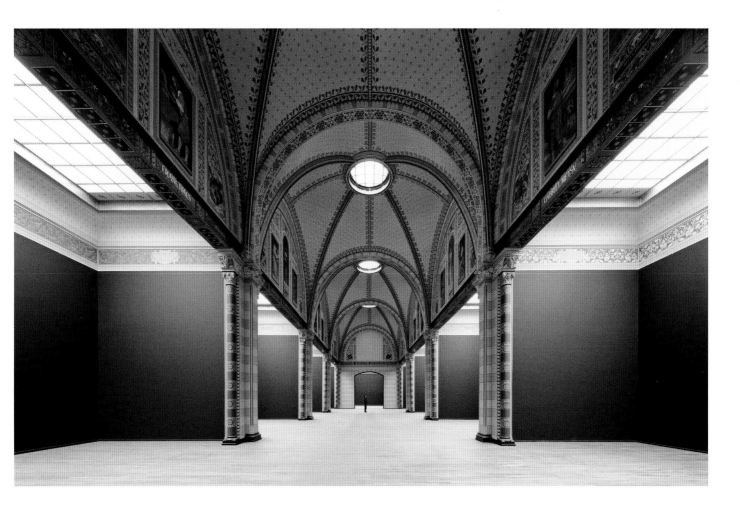

Gallery of Honour with canvases by Georg
Sturm (left: Gelderland Province with arts and
craft furniture makers, right: North Brabant
Province with arts and craft sculpture)

Sacral light in the Gallery of Honour comes
solely from within the galleries, the integrated
acoustic insulation hides behind the Sturm
canvases.

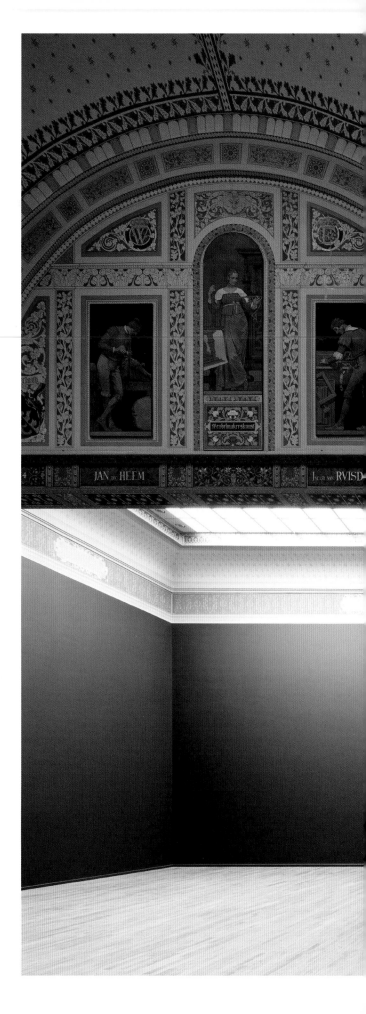

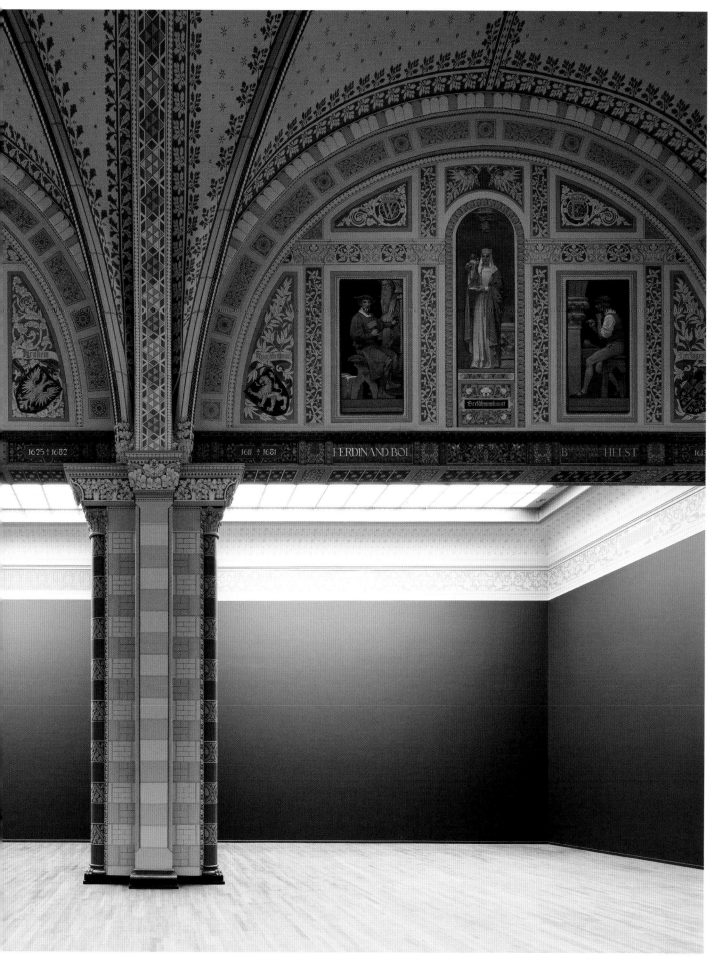

1625 † 1682 1611 † 1681 FERDINAND BOL BARTHOLOMEUS VAN DER HELST 161

The inner courtyards: function

In Cuypers' initial drawings the inner courtyards served as entrances into the building. Bowing to pressure from the municipality, the entrances were subsequently repositioned on the north façade and the staircases to the south. Later in the planning, an entirely new floor was added to the building.

For this purpose the courtyards were lowered to increase the amount of daylight entering the new addition. As a result, the floor differed in height with the passage. This project caused the west- and east wing to be connected solely via the main floor. As a consequence a new structure was built that linked both wings of the building with each other at ground floor level. However, this connection was impeded by the location of the toilets. In 1967, several options entailing the construction of a mezzanine in the underpass were suggested to create a possible connection with the intermediate level. None of these proposals were accepted, which turned out to be advantageous for the passage and the building itself.

The idea to once again make the inner courtyards the entrance to the museum was part of the renovation project. After the demolition of the temporary exhibition rooms that were present, the already lowered area beneath the underpass was lowered to a further depth of -0.85, thus connecting both courtyards beneath the passage. The courtyards are interpreted as uniform: In Cruz y Ortiz's original proposal the newly created interior space was accessible through an opening in the central part of the room beneath the passage. This would allow for the museum's entrance to finally be at its most logical position on the building's symmetry axis, in the form of a new public square connecting the east- and west wing to each other. This proposal was rejected because of opposition from cycling organisations and the RAK (spatial planning framework) and possibly also the municipality. It was eventually decided to keep the passage in its former capacity and to place the entrances

parallel to the newly unveiled courtyards at four locations, namely: two revolving doors and two symmetrical on both sides of the lifts located in the underpass.

Cuypers' project was based on the north-south symmetry axis that, as already mentioned, connected the existing town and its impending southward expansion. In those days the north façade – which overlooked Amsterdam's old historic centre – housed the entrances and prominent features (main towers, Grand Hall). In the current project, new orientations are being added on the east-west axis by connecting both courtyards with each other. This logical decision now links both the east- and west wing and solves the building's chronic logistical problem.

The inner courtyards form the heart of the new museum. Every facility of importance to a modern museum is found here. The public square is one large atrium with space for information- and ticket booths, a cloakroom, restaurant etc. The basement beneath the underpass houses among other things an auditorium, shops, a kitchen and storage space.

With regard to the restoration of the façades of both courtyards, a number of architectural elements that were a part of the first exhibition in the museum are included in the new architecture. Stained-glass windows have been reinstated and the skylights from fully framed windows now serve as air-conditioning facilities. 'Stained-glass' is converted to 'air and brass'. In other words, brass top-lights in the courtyard windows now extract the stale air.

Cruz y Ortiz suggested applying a second window layer under the glass roof of the inner courtyards. A so-called 'velum'. Cuypers' initial concept to perfect the roof above the two courtyards with double-glazing is hereby redressed and a structure has been created for the chandelier that hangs from it. Velum also complements the exhibiting function of the space because it hides the maze of structural lines and cables and establishes a visual connection

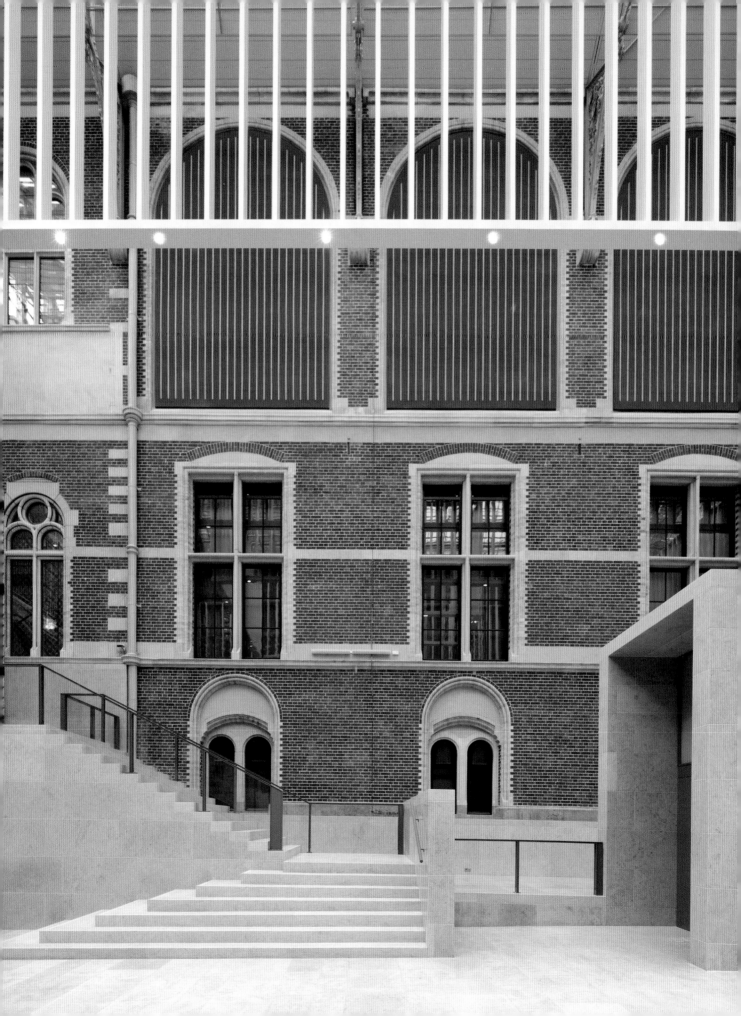

between the courtyards and the exhibition galleries on the main floor. The velum consists of aluminium panels that regulate incoming light. It acts as a background to the chandelier without accumulating dust, thus achieving the same effect as Cuypers' convex glass.

As already mentioned, the logical order through the underpass, the restored courtyards and the staircases that lead to the museum's entrance form the heart of the new Rijksmuseum. In addition, nineteenth century and contemporary architecture have been combined in this new architectural work. Consider the changes that needed to be made to the underpass and the space beneath it, including the new floors, stairs, lifts and principally the new chandeliers that hangs in the courtyards. These satisfy several functions: offer a unified ceiling height to both inner courtyards, emphasise the new east-west orientation, enable both the passage and the skylight to be clearly seen, obscure the more modest parts of the courtyard façades, help regulate acoustic conditions, and lastly add a modern and impressive feel to the surroundings. The chandeliers also play an important role in the scattering and shadowing effect of the light.

Interior: ornamental elements and exhibition
Two types of interior decoration are clearly recognisable in the building. Firstly, there are spaces such as the main staircase, the Grand Hall and the library. Here, the ornaments are an extension of the architectural spaces and give the best insight into Cuypers' architectural thoughts in relation to decor. Cruz y Ortiz were of the opinion that these should be wholly restored in order to gain a clearer understanding of Cuypers' perspective on interior ornamentation.
By restoring these spaces, the exceptional and distinctive mark left by Cuypers on the Rijksmuseum will be preserved.

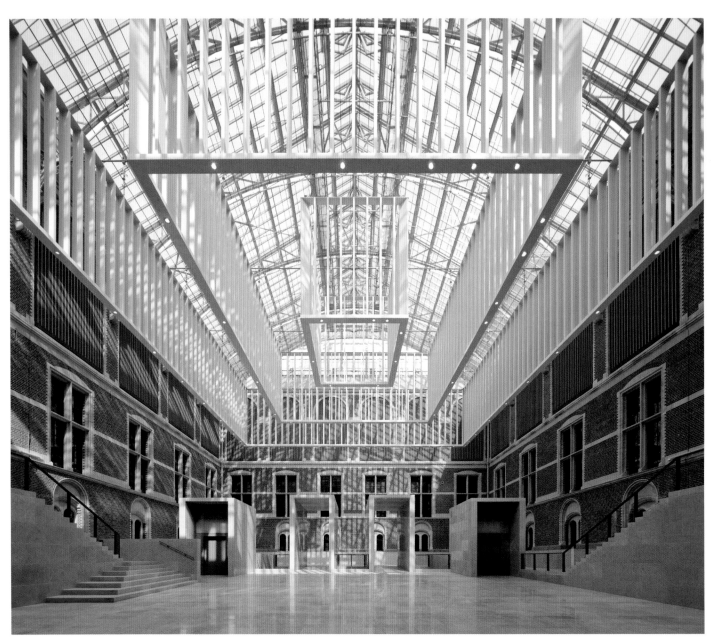

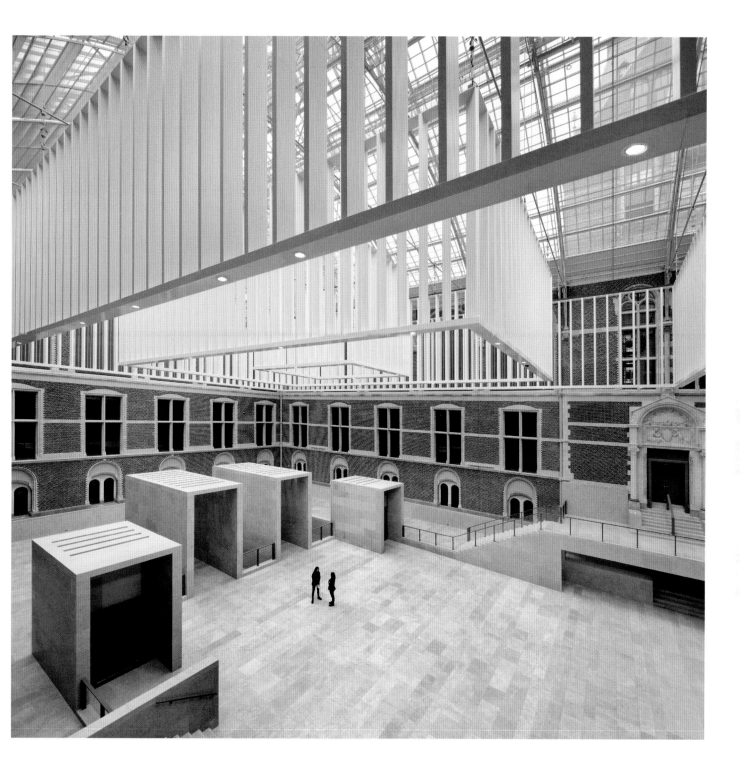

The new chandeliers capture the riveting play
of light and shadow on the floor and façades.

The chandelier construction as a 'gothic' ceiling
in the space with a human dimension.

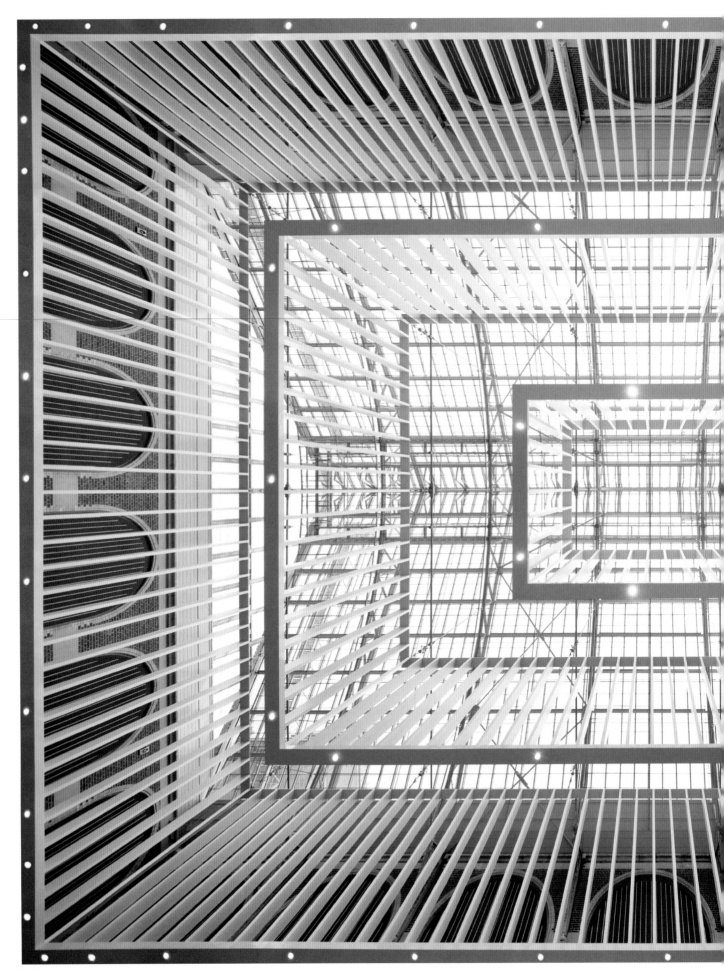

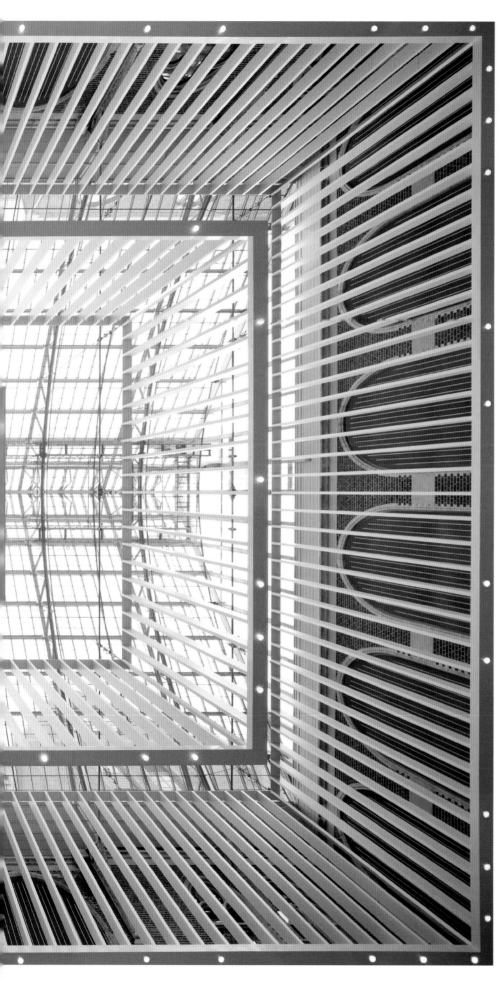

The chandelier gives the Rijksmuseum its new identity and is symbol of the heart of the building.

page 24 / 25
By opening up the courtyards and the windows the underpass achieves the allure of an entrance worthy of a museum.

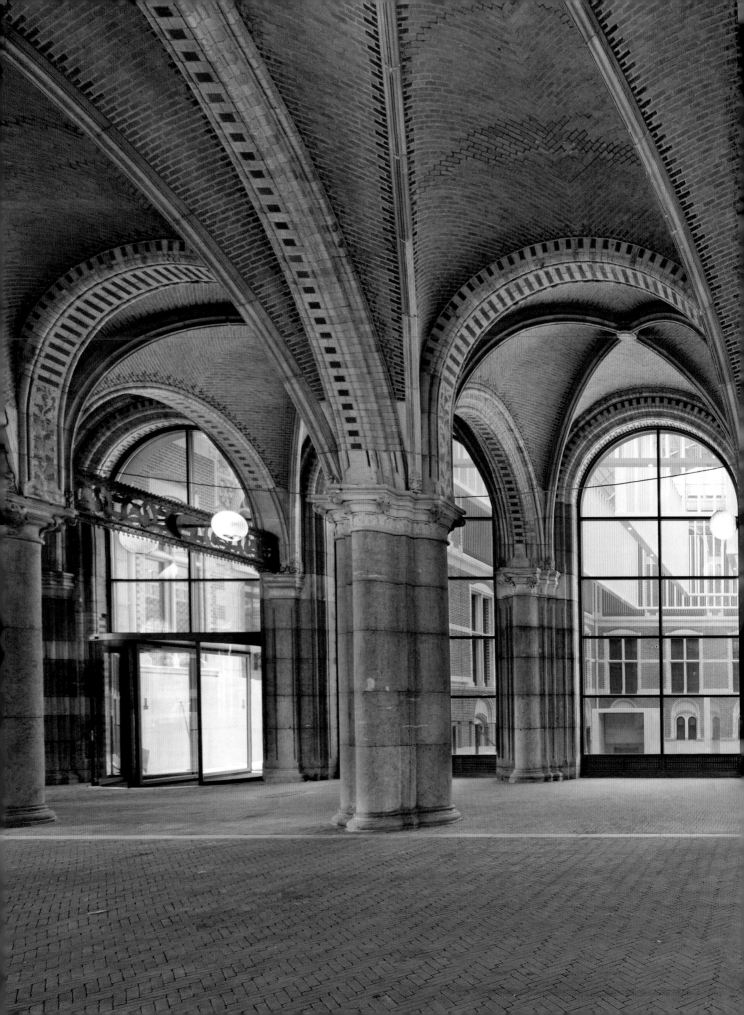

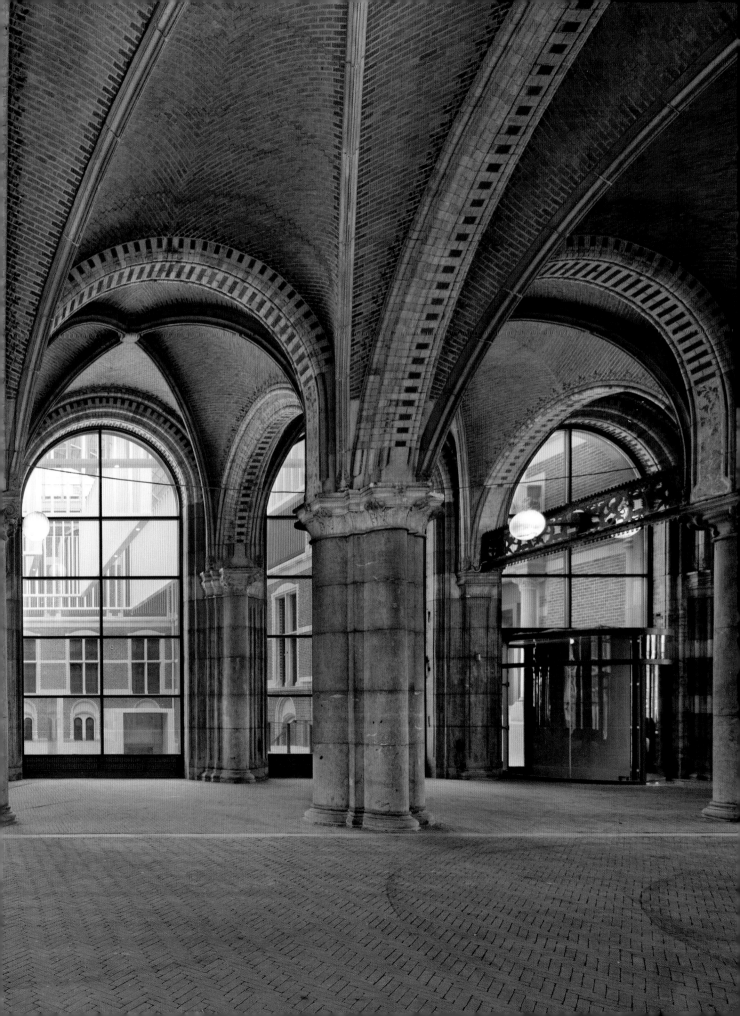

Secondly, there are the ornaments found in the exhibition spaces. These were designed as a means of assistance, to emphasise each of the designated sections and give a clearer understanding of the original museum content. These ornaments often bear the form of an architectural element like a column or arch, such as those found in the eastern basement. Most of these sections have housed objects and time periods other than that for which it was originally designated. Moreover, views on the function of a museum have drastically changed since the end of the nineteenth century. At the time, the ideas of Cuypers and De Stuers were already being regarded as a little too conservative by some of their contemporaries. Today, exhibited work and the correct interpretation of that work by visitors is of the highest importance and is often at the expense of other demands. Since this elicited objections by the inspecting body, commitment to the former, with regard to renovation, limited the possibility of recovering 100% of the spatial structure.

Main staircase and grand hall
The main staircase, Grand Hall, Gallery of Honour and Night Watch Gallery form a coherent whole in line with the ambitions of their architect. These spaces are practically renovated in their entirety, including the canvases of Sturm, terrazzo flooring and panelling.

Gallery of Honour
Bearing in mind that the renovation of the Grand Hall and the Night Watch Gallery redresses their original positions, a permanent passageway through the Gallery of Honour has been constructed to connect them with adjoining galleries. As a consequence, the Gallery of Honour regains (especially in its central niche) its original ornamentation. Even the lighting, as Cuypers had envisioned, has been successfully recreated: sacral light floats down into the galleries whereby the main nave, with almost ceremonial approach, guides the now softened light further into the Night Watch Gallery and illuminates the Night Watch.

Night Watch Gallery
The ornamentation in the Night Watch Gallery have been renovated, from the supporting beams to the arches beneath the skylight. Even the restoration of the columns have been modelled on Cuypers' architectural ideas on ornamentation and the exposition room as universal artwork (*Gesamtkunstwerk*). The floor is fitted with wood as are the floors in the remaining exhibition spaces.

Vermeer Extension
The Vermeer-extension is a special layout that was designed by Cuypers. It allowed visitors to admire the Night Watch in the best possible light. To achieve this, the painting was hung in such a way that it was exposed it to the same daylight it had received whilst being painted: from the left. This particular approach had a specific architectural consequence – the original strict east-west symmetry was broken.

When the painting was returned to the Rembrandt Gallery, it highlighted a tricky problem. This space actually requires an entrance and an exit in order to improve the route and logistics around the Vermeer extension as well as the Night Watch. This would have been the best solution from an architectural perspective. However, this option wasn't approved by the inspecting body.

In order to create a second entrance, the tile tableaus situated on the west side of the old façade of the museum would have to be removed and placed elsewhere within the building. Possibly outside – showcased as an exhibition-element in the garden. The central panel would remain unseen in the room, hidden behind a false wall, because the contrast between the refined Night Watch and the almost 'cartoony' caricatures on the tableaus would be too extreme.

The Cuypers library

The large reading room remained. This means that the alterations that were made in the past will be reversed and the original features, which are still largely discernible, properly restored. In the twentieth century a staff- and book lift had been installed in the library hall to connect the library with the adjoining galleries. The lift is restored in keeping with the rest of the library. The terrazzo floor in the reading room has also been restored, as well as the ornaments in the adjacent semi-public rooms.

Passage

In the underpass or passage, the original architecture was respected, but the necessary course of action was carried out to create the new entrances to the museum.

Connecting the main building with the Philips wing

The corridor on the ground floor, which connects the south wing with the main building, was originally a secondary element. This was evident from the low ceiling, the small windows and low section of the side façade of the library building. This corridor forms a very important connection between the courtyards - the heart of the museum - and the Philips Wing, where the department houses temporary collections, *blockbusters*, the friends room and restaurant. The entrance to the Pavilion for Asiatic Art connects at the end of this corridor.

During the renovation the existing ceiling was raised. Lowering the balustrade on the windows and removing the natural stone piers created a more open atmosphere, making the windows bigger and increasing the amount of air and light flooding the corridor.

Exterior

Renovation of the exterior of the building, where emphasis is on conservation and integral restoration of façades and roofs with new skylights.

Teekenschool (Drawing School)

As well as in the main building, the Rijksmuseum also 'Continues with Cuypers' in other areas: not only has the building and the original function of the Teekenschool been fittingly restored in a contemporary fashion, a high level of ambition was also pursued. The Teekenschool has become one of the most important museological education centres in Europe, defining a new way for visitors to experience the collection. Under the motto 'learning to look by doing' the Teekenschool organises a varied range of activities specifically designed for children (in school groups or with families) in three modern studios, which include drawing, art appreciation, theatre, photography and multimedia. The starting point is always (a visit to) the collection in the main building. The Teekenschool was established in 1892 and was conceived and designed by Cuypers. For a number of years it housed both precursors of the Gerrit Rietveld Academie - the Rijks Normaalschool voor Teekenonderwijs and the Rijksschool voor Kunstnijverheid. Hence, the building is restored to its original function, but modernised for today.
The building is connected on the first floor to the study centre via the west façade. According to historical research the chapel is the building's most cherished space and is used as a study area or conference room. The major part of the restoration work was carried out in this section of the building.

Villa

The former director's villa is now in use as an office by the museum curators, as was also the case in previous years.

Asian pavilion

The new natural-stone Pavilion for Asiatic Art, whose collection doesn't fit in the chronological timeline that characterises the exhibition in the main building, eventually finds its landing site in the southern half of the garden - there where Cuypers had also created a less symmetrical and more picturesque portrait through the building extensions of his time. The Pavilion is part of the garden design where it is integrated as 'folly' or 'objet trouvé'. The tectonics and the detailing - such as the massive stone corners - but also the visual presence of the fifth façade, namely 'the roof', are a modern interpretation of Cuypers' perspective.

Cruz y Ortiz arquitectos

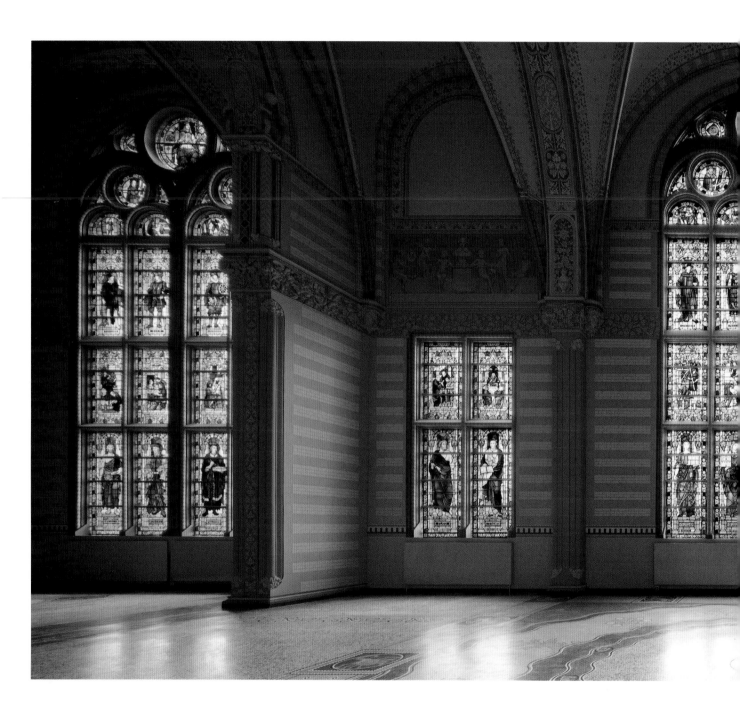

Stained-glass windows in the Grand Hall
designed by Pierre Cuypers.

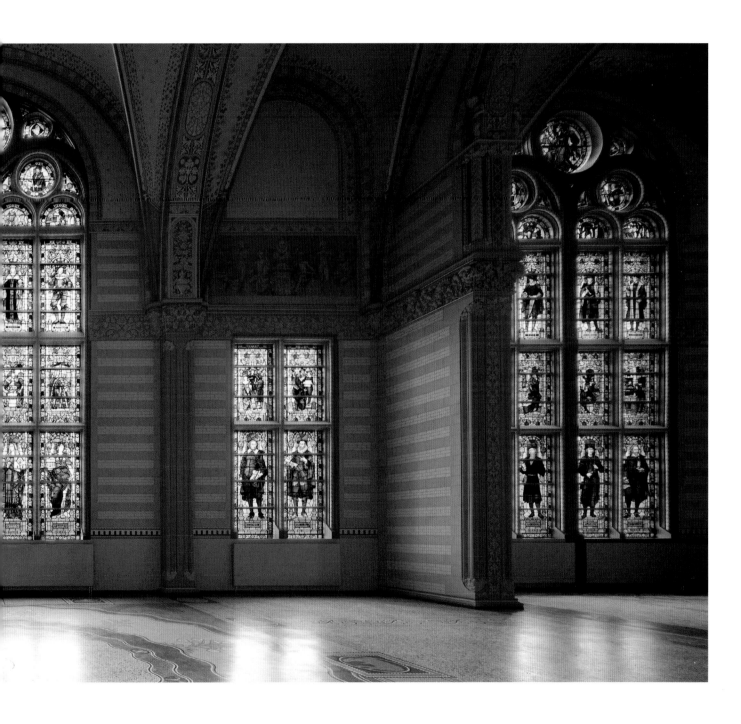

New museum in the Rijksmuseum

The newly renovated Philips Wing opened its doors again to the public on 1 November 2014. The restoration of the wing was commissioned by the Rijksgebouwendienst (English equivalent: Historic Buildings and Monuments Commission for England – English Heritage). Spanish architects Cruz and Ortiz signed on to oversee this major project.

On this special opening, the Rijksmuseum organized a spectacular photo exhibition titled "Modern Times – Photography in the 20th century". The exhibition drew attention to such developments as the breakthrough of photography as an art form and as a journalistic medium. As many as 400 photographs were exhibited, including works from world-famous photographers such as Man Ray, Lâslo Moholy, Nagy and Helen Levitt.

The new exhibition wing of the Rijksmuseum, with larger and smaller (inter)national exhibitions has a very rich collection of photographs. The newly renovated galleries consist of 13 exhibitions spaces and the RIJKS RESTAURANT, a large restaurant with sun terrace. A new culinary concept has been developed for the restaurant with top chefs rotating in turn in much the same manner as guest curators.

Wall from breda

The Philips Wing houses historic building fragments from wholly different origins; the South Water Gate from Gorinchem, the Ockingastin's Staircase Tower in Franeker, the Arches from the stairwell from the house of Constantijn Huygens in the Plein in The Hague and the so-called Wall from Breda. The latter is a piece of the "first renaissance palace located north of the Alps". That palace was located in Breda. It was partially demolished and Cuypers personally oversaw the transportation of this piece to the Rijksmuseum. The Wall from Breda can be viewed in the beautiful, small atrium in the Philips Wing.

Summer-house

in honour of its opening, the Green Outdoor Gallery is enriched with an 18th century summer-house at the front of which is a black and white tiled floor where at periodic times visitors can indulge in a game of chess using large chess pieces.
The collection of historic building fragments has been expanded with the addition of one of the icons of the new pragmatism: the telephone booth from Brinkman & Van der Vugt from 1931-1932.

The Spanish architects have added a bright new chapter to the already rich history of the Philips Wing, thus for the second time, the building has received more light.

The construction of a wall from the city Breda (de Bredase muur) in the small atrium of the Philips wing.

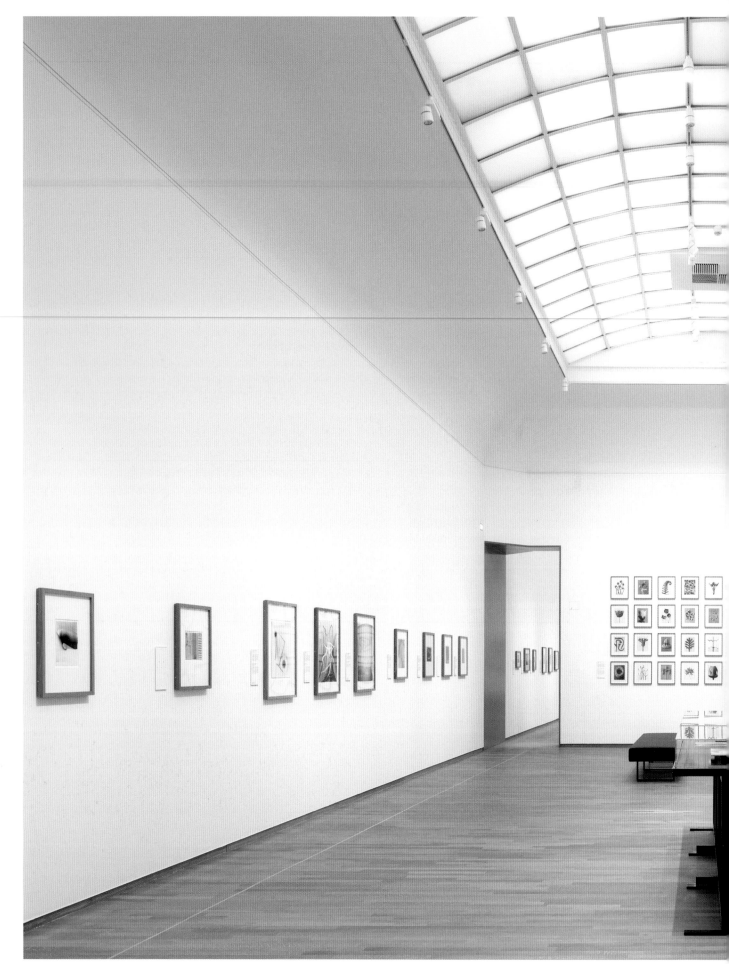

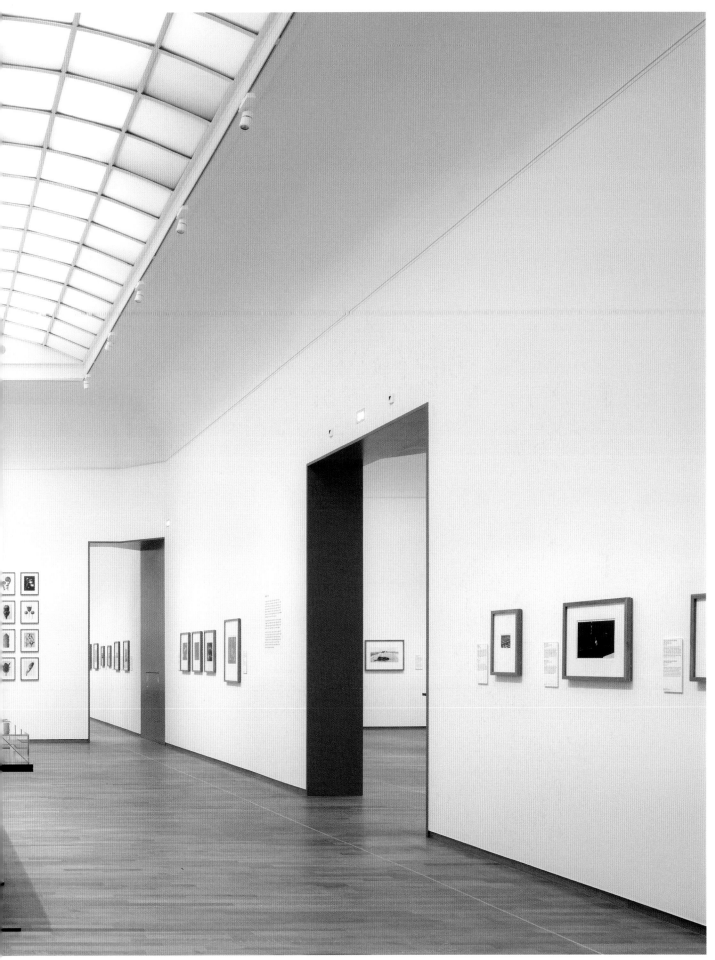

Display of works in one of the 13 exhibition
galleries of the Philips wing.

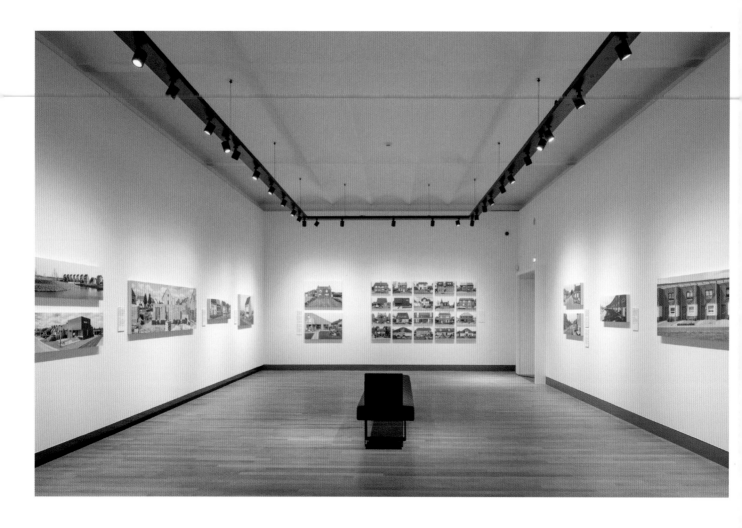

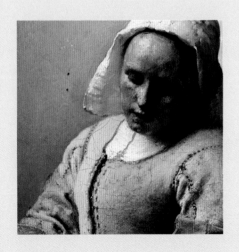

The collection

The Rijksmuseum first opened its doors in 1800 under the name 'Nationale Kunstgalerij'. At the time, it was housed in Huis ten Bosch in The Hague. The collection mainly comprised paintings and historical objects. In 1808, the museum moved to the new capital city of Amsterdam, where it was based in the Royal Palace on Dam Square. On 19 November 1798, more than three years after the birth of the Batavian Republic, the government decided to honour a suggestion put forward by Isaac Gogel by following the French example of setting up a national museum. The museum initially housed the remains of the viceregal collections and a variety of objects originating from state institutions. When the Nationale Kunstgalerij first opened its doors on 31 May 1800, it had more than 200 paintings and historical objects on display. In 1808, the new King Louis Napoleon ordered the collections to be moved to Amsterdam, which was to be made the capital of the Kingdom of Holland. The works of art and objects were taken to the Royal Palace on Dam Square, the former city hall of Amsterdam, where they were united with the city's foremost paintings, including the *Night Watch* by Rembrandt. In 1809, the Koninklijk Museum opened its doors on the top floor of the palace. A few years after Willem I returned to the Netherlands as the new king in 1813, the 'Rijks Museum' and the national print collection from The Hague relocated to the Trippenhuis, a 17th-century town-palace on Kloveniersburgwal in Amsterdam. The Trippenhuis proved unsuitable as a museum. Furthermore, many people thought it time to establish a dedicated national museum building in the Netherlands. Work on a new building did not commence until 1876, after many years of debate. The architect, Pierre Cuypers, had drawn up a historic design for the Rijksmuseum, which combined the Gothic and the Renaissance styles. People considered it too mediaeval and not Dutch enough. The official opening took place in 1885. Nearly all the older paintings belonging to the City of Amsterdam were hung in the Rijksmuseum alongside paintings and prints from the Trippenhuis. The collection of 19th-century art from Haarlem was also added to the museum's collection. Finally, a significant part of the Kabinet van Zeldzaamheden, which had by then been incorporated into the new Netherlands Museum for History and Art, was returned to Amsterdam. Over the years, collections continued to grow and museum insight continued to expand, and so the Rijksmuseum building underwent many changes. Rooms were added to the south-west side of the building between 1904 and 1916 (now the Philips wing) to house the collection of 19th-century paintings donated to the museum by Mr and Mrs Drucker-Fraser. In the 1950s and 1960s, the two original courtyards were covered and renovated to create more rooms. In 1927, while Schmidt-Degener was Managing Director, the Netherlands Museum was split to form the departments of Dutch History and Sculpture & Applied Art. These departments were moved to separate parts of the building after 1945. The arrival of a collection donated by the Association of Friends of Asian Art in the 1950s resulted in the creation of the Asian Art department. The current renovation reinstates the original Cuypers structure. The building work in the courtyards are removed. Paintings, applied art and history are no longer displayed in separate parts of the building, but form a single chronological circuit that tells the story of Dutch art and history.

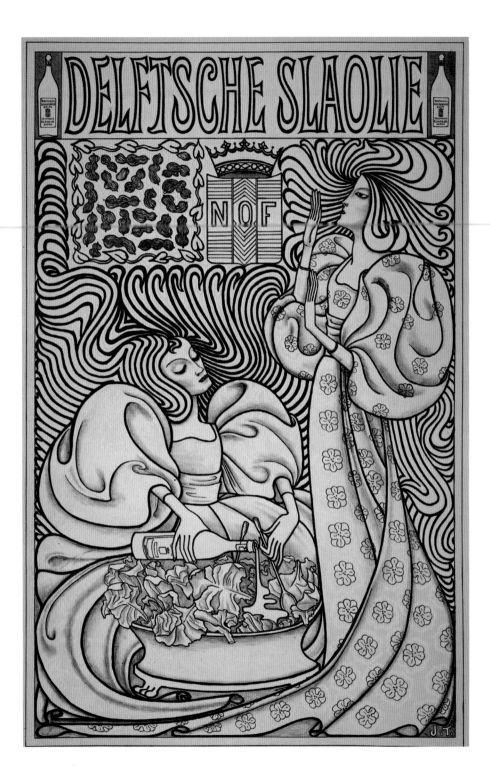

Jan Toorop. *Poster for Delft Salad Oil, 1894.*
Two women with wavy hair and billowing occupy most of the composition. One of them is dresing a salad. The poster became an icon and lent Dutch Art Nouveau its nickmane, salad oil style. Jan Toorop is born in Poerworedjo in 1858.

George Hendrik Breitner. *Girl in a White Kimono, 1894.*
Inspired by Japanese prints, Breitner made at least twelve paintings around 1894 of a girl in a kimono. She assumes different poses and the kimono often has a different colour. The dreamy girl is the sixteen-year-old Geesje Kwak, a hat-seller and one of Breitner's regular models.

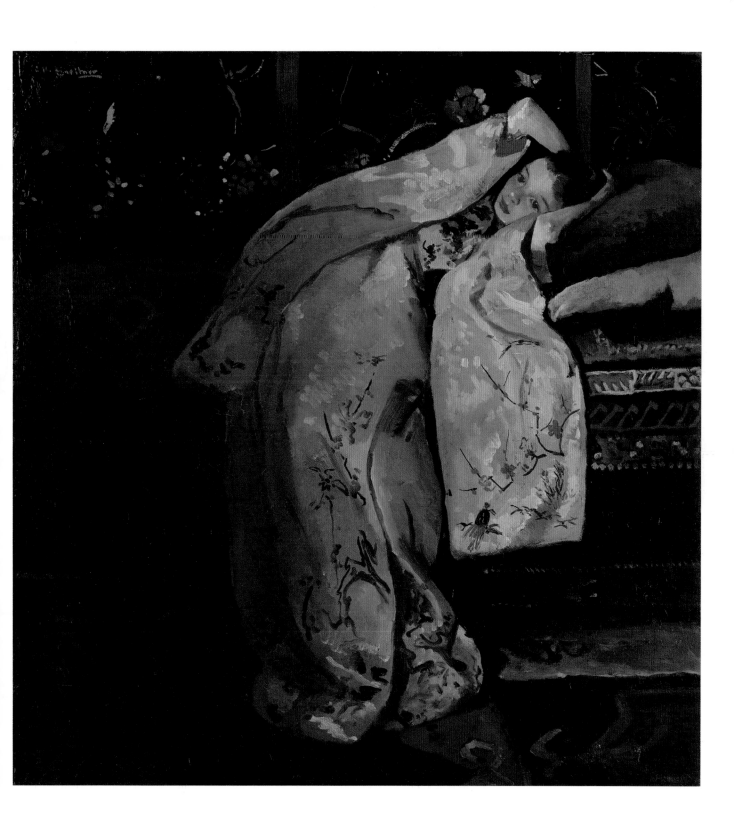

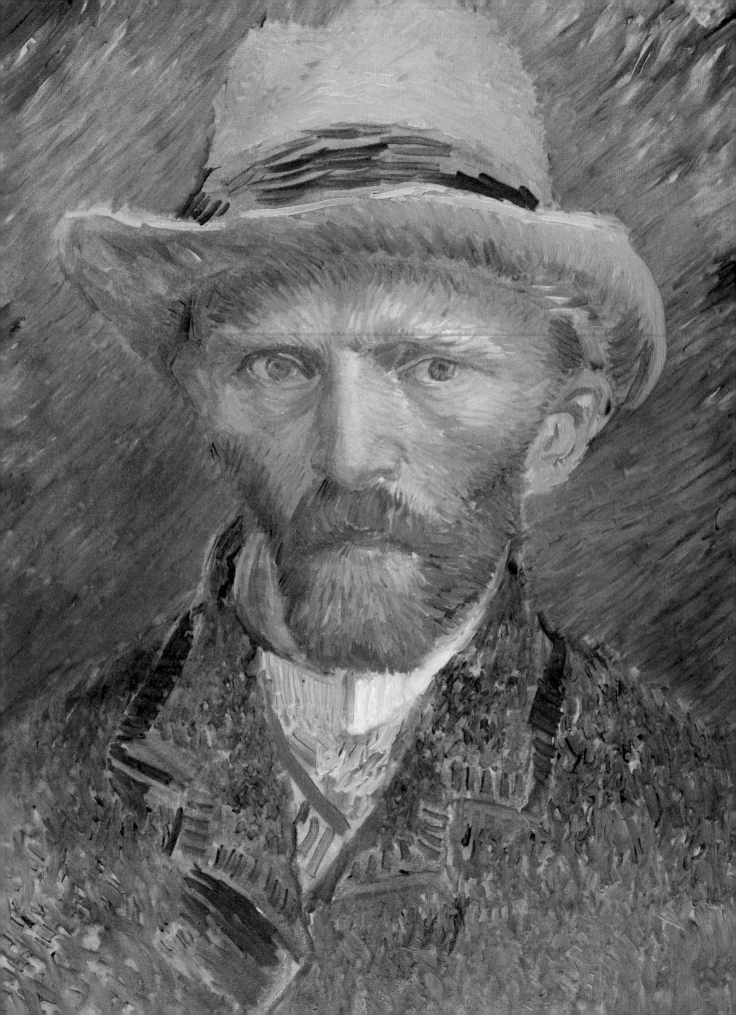

Vincent van Gogh. Self-portrait, 1887.
Van Gogh moved to Paris in 1886, after hearing
about the new colourful style of French painting.
To avoid having to pay for a model he painted
several self-portraits in rhythmic brushstrokes
in striking colours. He portrayed himslef as a
fashionably dressed Parisian.

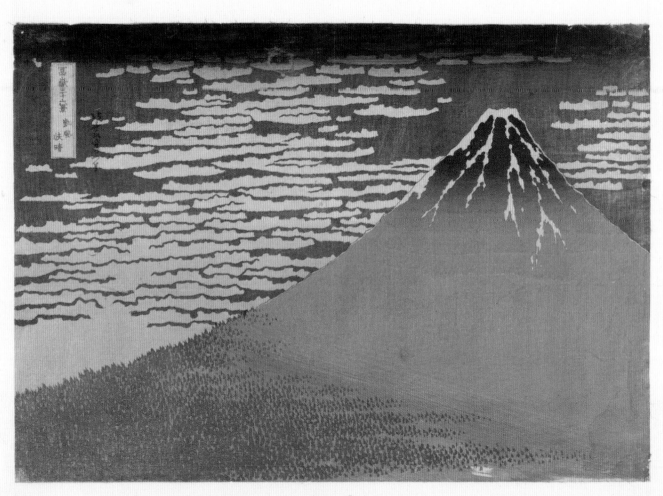

Katsushika Hokusai. Mount Fuji, 1829-1833.
Clear weather with a southerly wind, Nishimura
Yohachi
'Gaifu kaisei (Japanese title). 36 views on mount
Fuji. (Fuji sanjurokki). In red, white snow, dark
green forest, blue sky with white clouds. His first
woodblock printing appeared in 1799.

Model of warship William Rex. C. Moesman, Agriaen de Vriend, 1698.
A model of a Dutch warship William Rex, with 74 guns, in the late 17th century. It was made at the dockyards of Vlissingen (Flushing), were real warships were also built. These warships wpuld have been twelve times larger than this model. This model was displayed in the council chamber of the Admiralty of Zeeland in Middelburg.

Wedding dress. Anonymous, c. 1750-1760. Light blue embroidery silk with a floral motif. Complete wedding of with multicolor silk.

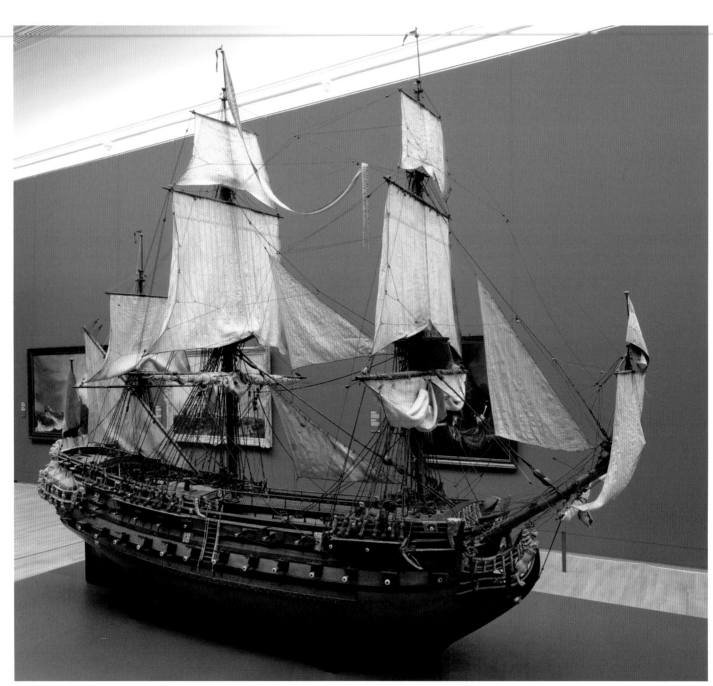

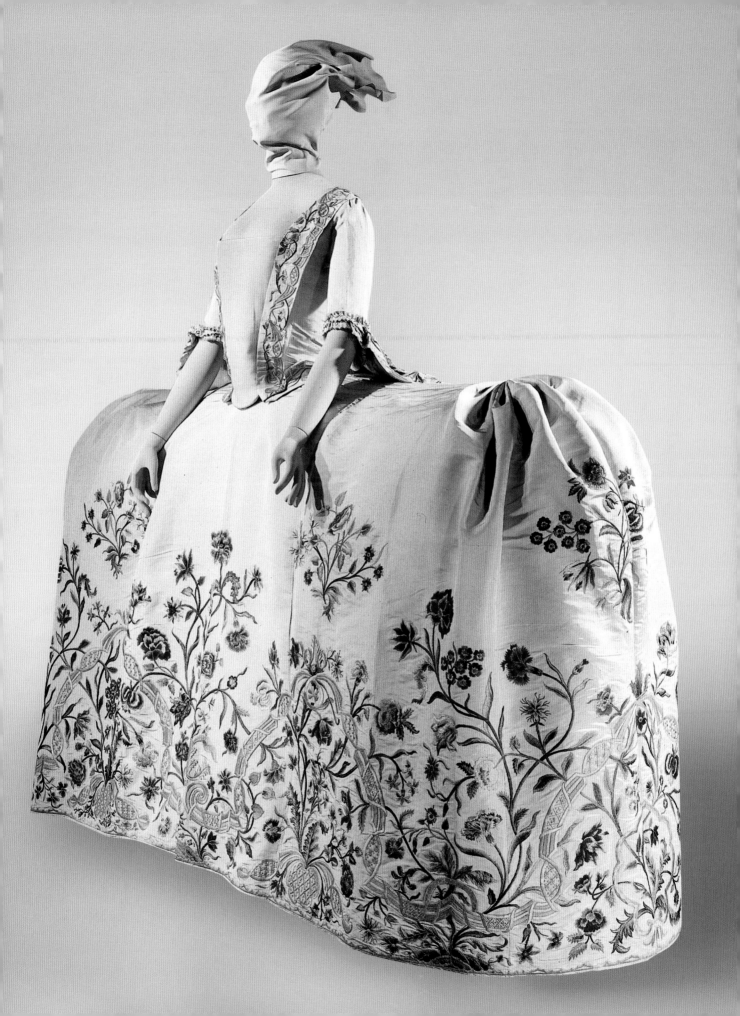

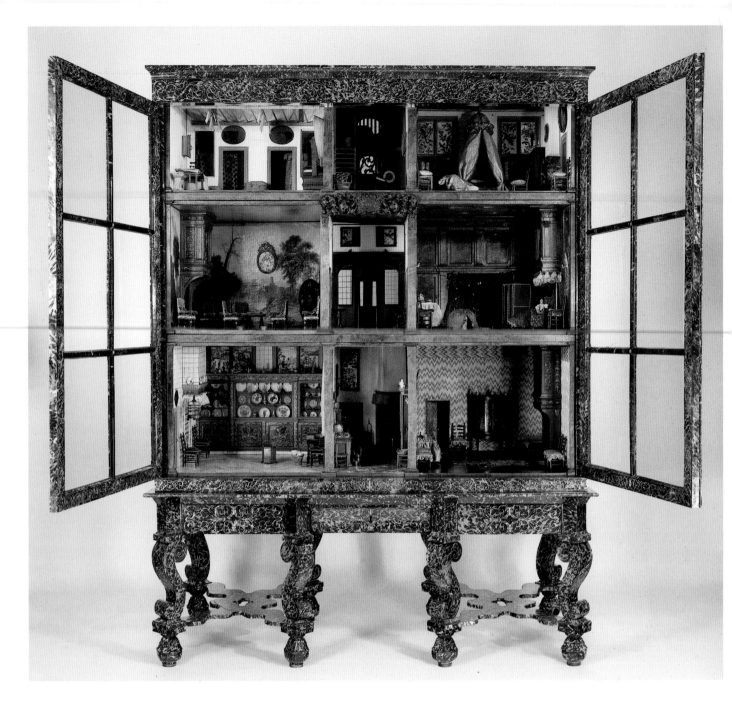

*Dolls' house of Van Petronella Oortman,
Anonymous, c. 1686-1710.*
Exeptionally realistic. All contents have been
made of authentic materials and the propor-
tions are exactly correct. Made by a cabinetmak-
er from France who worked in Amsterdam for
several years. Petronella Oortman was married
with the merchant Johannes Brandt.

Johannes Vermeer. The Milkmaid, c. 1660.
A maidservant, entirely absorbed in her work.
Exept for the stream of milk, everything else is
still. Vermeer took this simple everyday activ-
ity and made it the subject of an impressive
painting – the woman stands like a statue in the
brightly lit room.

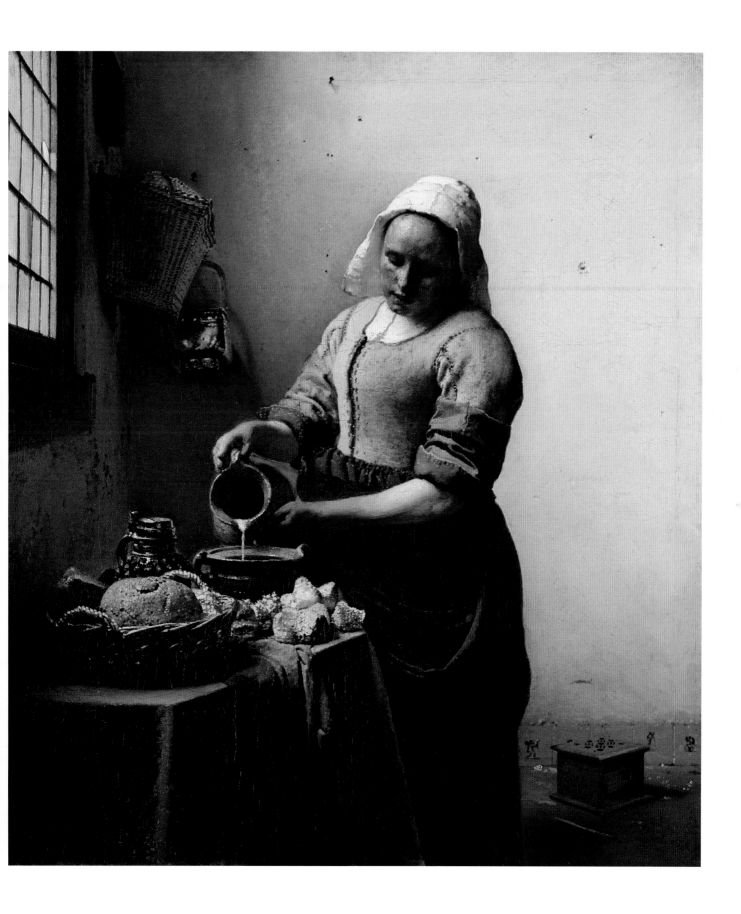

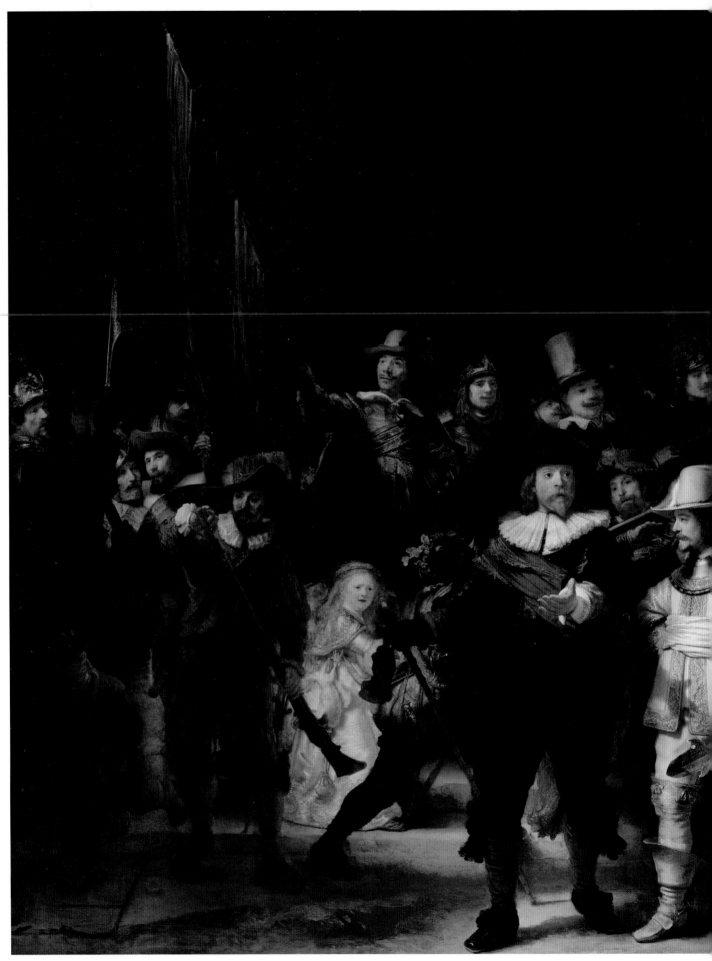

Rembrandt Harmensz. van Rijn. Night Watch, 1642.
This painting was made for the Arquebusiers guild hall.One of the several halls of Amsterdam's civic guards, the city's militia and police. The captain, Frans Banninck Cocq dressed in black, is telling his lieutenant, Willem van Ruytenburch to start the company marching. The young girl in the foreground is the company mascot.

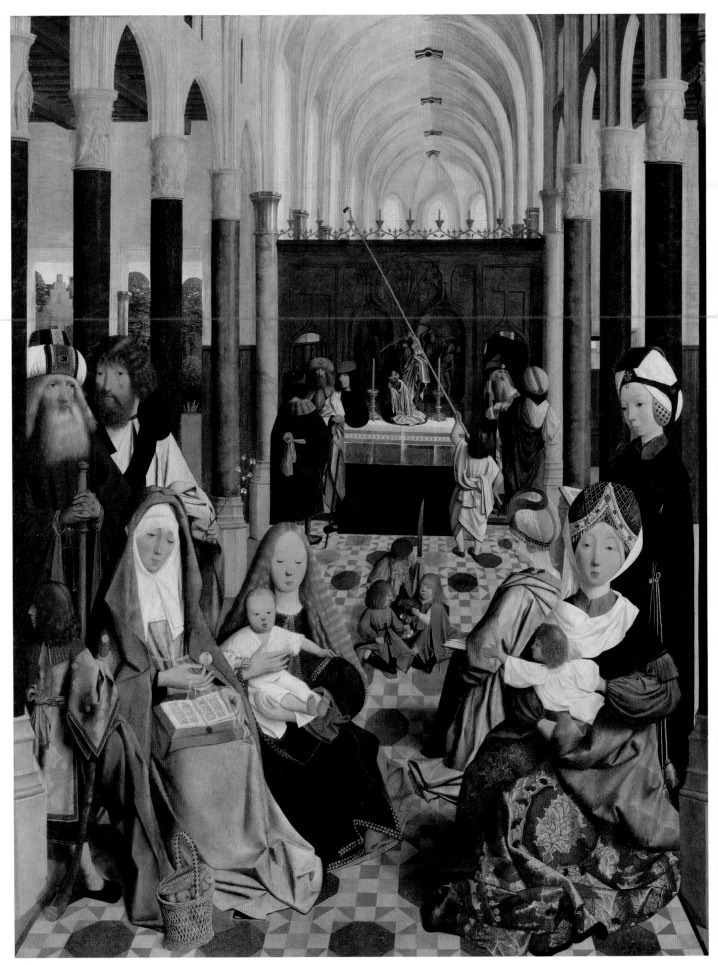

Geertgen tot Sint Jans. 1455/1465-1485/1495.
Geertgen was born in Leiden and died in
Haarlem.In 1480, Geertgent ook up residence at
St. John's Brethern monstery in Haarlem-hence
the name 'tot Sint Jans'. While not a monk he
worked for the order as a lay brother, painting a
large altarpiece for the church. Geertgen tot Sint
Jans has been hailed the founder of Northern
Nederlandish art.

Shiva Nataraja, Anonymous c. 1100-1200.
Shiva, as Nataraja (Kinf of Dancers), in the
anandatandava pose and encircled by a halo of
fire. Both the creator and destroyer of the world.
Richly decorated bronze figures of Hindu gods
were carried in processions on feast days.

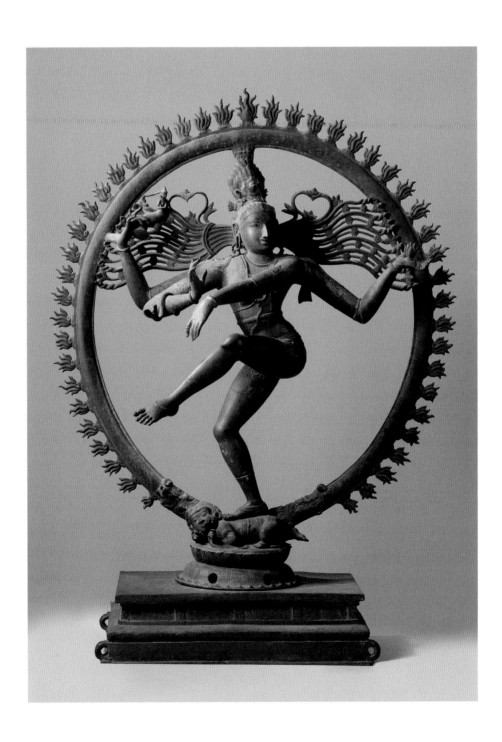

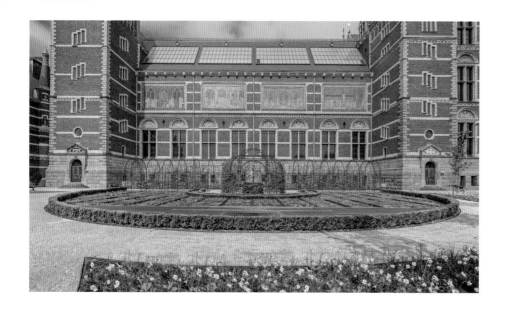

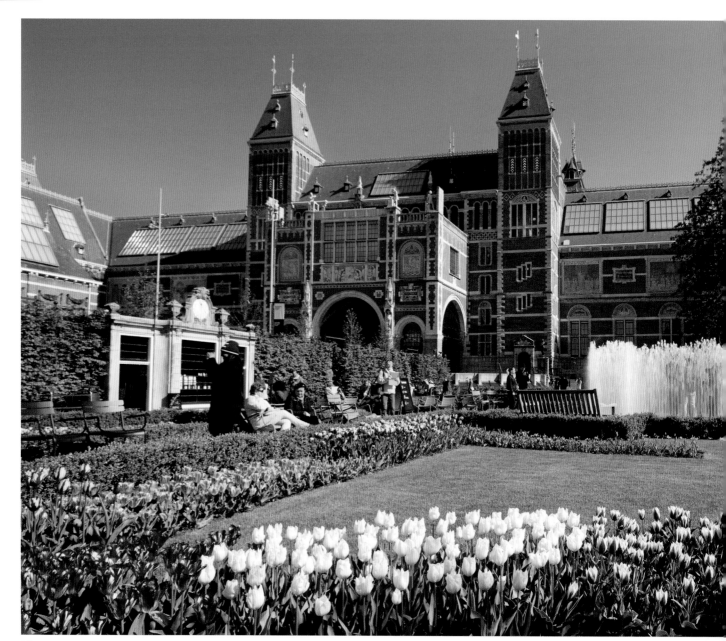

The green outdoor gallery

More thought for the young museum visitor

The gardens surrounding the Rijksmuseum have undergone an intensive metamorphosis, one based on Pierre Cuyper's original plans for the gardens from 1901. The new design is courtesy of Copijn Tuin- en Landschapsarchitecten in Utrecht (Copijn Garden- and Landscape Architects, Utrecht).

The garden is a reflection of the museum. Its main aim is to gently connect the various target groups with the world of art. The new museum policy is modified to include more thought for the young- and thus the future museum visitor. The designers improved and updated Cuyper's vision of a relatively accessible outdoor gallery to correspond with contemporary requirements. In addition to art, senses are further stimulated with scent, colour and gastronomy. Several of the original garden styles can be found in these renovated gardens, as well as classical sculptures and fragments of ornaments from historic buildings.

The 18th century Louis XIV style summer-house, a water pavilion based on a design by Danish artist Jeppe Hein, a 19th century French glass greenhouse with so-called 'forgotten' heirloom vegetables and a playground with playground equipment designed by architect Aldo van Eijck have all been given pride of place in the museum's public outdoor gallery.

The renovated gardens also house annual temporary sculpture exhibitions with internationally renowned sculptors. The first exhibition to be held in this outdoor gallery was the English sculptor Henry Moore in 2013. The American sculptor Alexander Calder has an exhibition of his sculptures from 21 June 2014 in the outdoor gallery of the Rijksmuseum.

The garden consists of two large pergolas (berceaux). One pergola (18) was trimmed back to its original size during planting. This green, deciduous, overgrown beech path has a cupola in the middle. The garden bench "De Visser" ("The Fisherman") (19) also has pride of place here.

The trendy naturalistic look (20) gives a contemporary and unique flair to the garden. Large groups of perennials

Pages 54 - 55:
The American sculptor Alexander Calder
in the outdoor Gallery.

alternate with flowering Eremurus, Persicaria and Aster in a bed of swaying grasses. The parterre of this berceau is covered with an almost creeping-type of grasses that includes Festuca and Koeleria, interspersed with flowering perennials such as Sedum, Geranium and Dianthus.

The 120-year-old wing nut tree (3) dominates this particular area by way of its mighty crown and ditto the garden with its immense root system. This monumental tree made it impossible for the original maze to be restored. Because of this, the designers altered the maze in the new plan and went with a natural stone tile panel in accordance with the original drawing.

The Sculptures pergola (5) was constructed on the basis of original drawings to line the periphery of the garden bordering the Museumstraat (Museum Street). Each sculpture occupies its own space in steel niches overgrown with hornbeam. The sculptures are arranged in a tight rhythm on both sides around the historic Van Logteren summer-house (6). Here, among others, are two statues by Bartholomeus Eggers (1674) cast in lead and Bentheimer sandstone and a beautiful sculpture of Apollo (1730) made from Bentheimer sandstone and based on a design implemented by Jan van Logteren. His Apollo is recognizable by the laurel crown.

Summer-house
The 18th century Louis XIV style summer-house originally stood in the inner courtyard of a townhouse located on the Amsterdamse Keizersgracht (Emperor's Canal in Amsterdam). During the demolition of the house, at the start of the 20th century, the summer-house was relocated to the Rijksmuseum. Only the facade and the sundial are original; the remainder of the house was added when it was placed inside the Rijksmuseum. The summer-house is made from sandstone and based on a design by Ignatius van Logteren in 1735. With fine weather, tea and coffee are available to visitors to the garden.

Water pavilion
The Danish artist Jeppe Hein designed a water pavilion (7) titled "Hide and See(k)", which is located on the forecourt of the summer-house. This is a modern variation of an old tradition. Sometimes 'trick fountains' were added to 17th century geometric baroque gardens. Hidden fountains are also known to turn unexpectedly on and off with this Danish artist. Lots of children have been caught unawares by his waterworks.

French glass greenhouse
The 19th century French glass greenhouse (12) is a new historic element in the garden collection. In this greenhouse, vegetables and herbs were cultivated that were a lot more common in the early Dutch kitchen than they are today. Examples of these in the wrought-iron arched greenhouse would be Rhubarb, Common Scurvy Grass and Cardoon, but there were varieties of Broad Beans and Legumes too. With the cultivation of these vegetables, a connection between paintings, cultivation and the new restaurant was established. We're talking about edible crops, which are also documented on seventeenth-century paintings in the museum's collection.

Playground equipment
There are also playground equipment (16) in the garden for the first time, and namely from architect Aldo van Eijck. These have been positioned at the foot of the Villa, the new construction by Cruz and Ortiz and the Teekenschool. It corresponds perfectly with the contemporary design of the garden, and the thought for the young museum visitor. The playground equipment are made of aluminium and come from Osdorp. Seven pieces of playground equipment are placed here: a climbing tower, a funnel climber, the characteristic igloo climbing dome and two arc climbers and a bridge. This historic playground equipment, together with the maze and the water labyrinth, add to the garden's playful and educative approach.

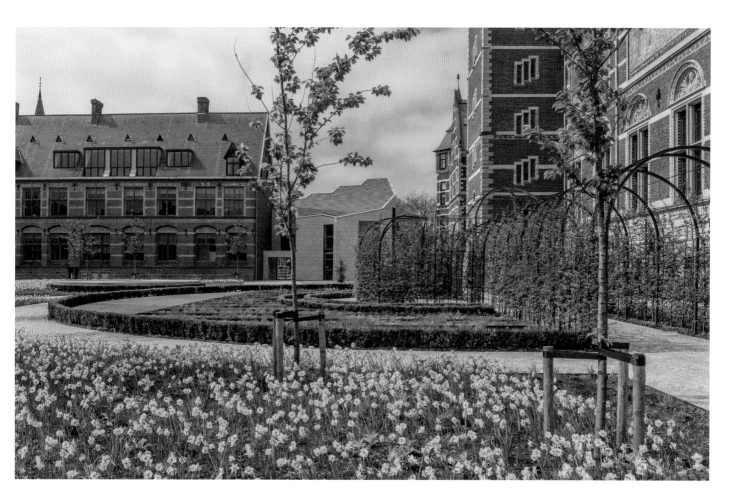

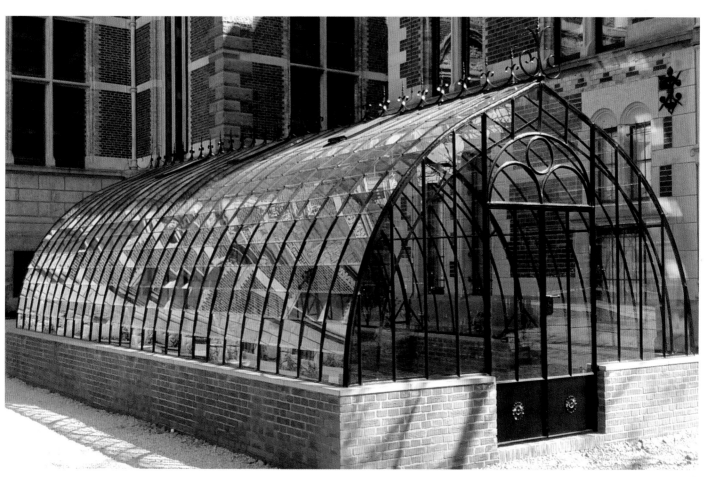

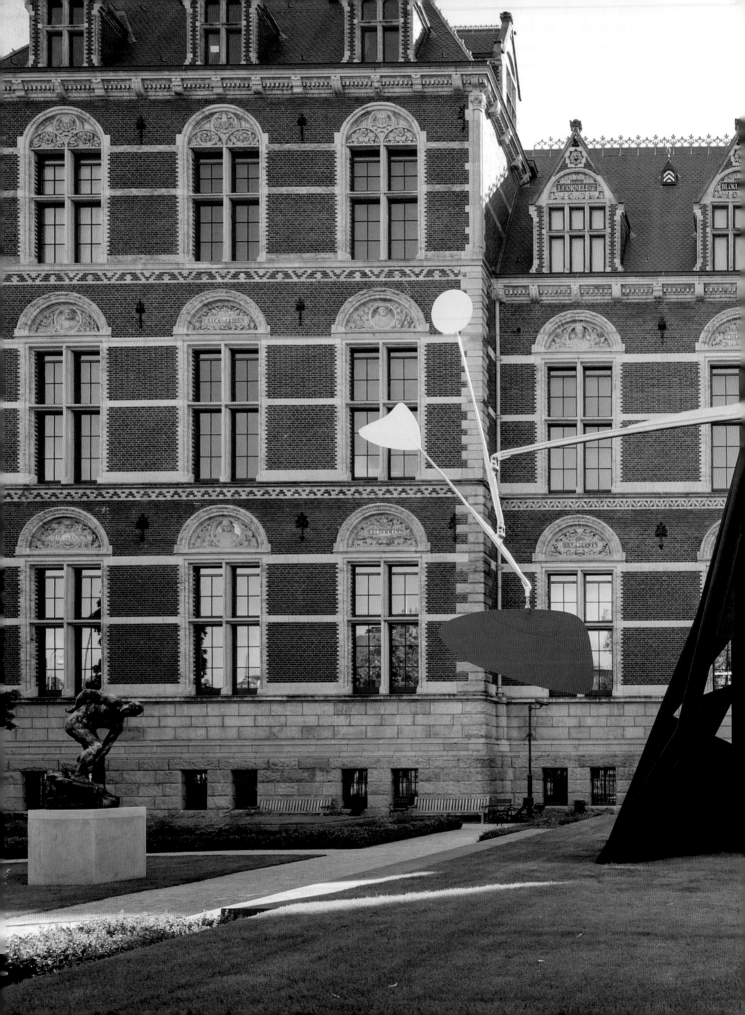

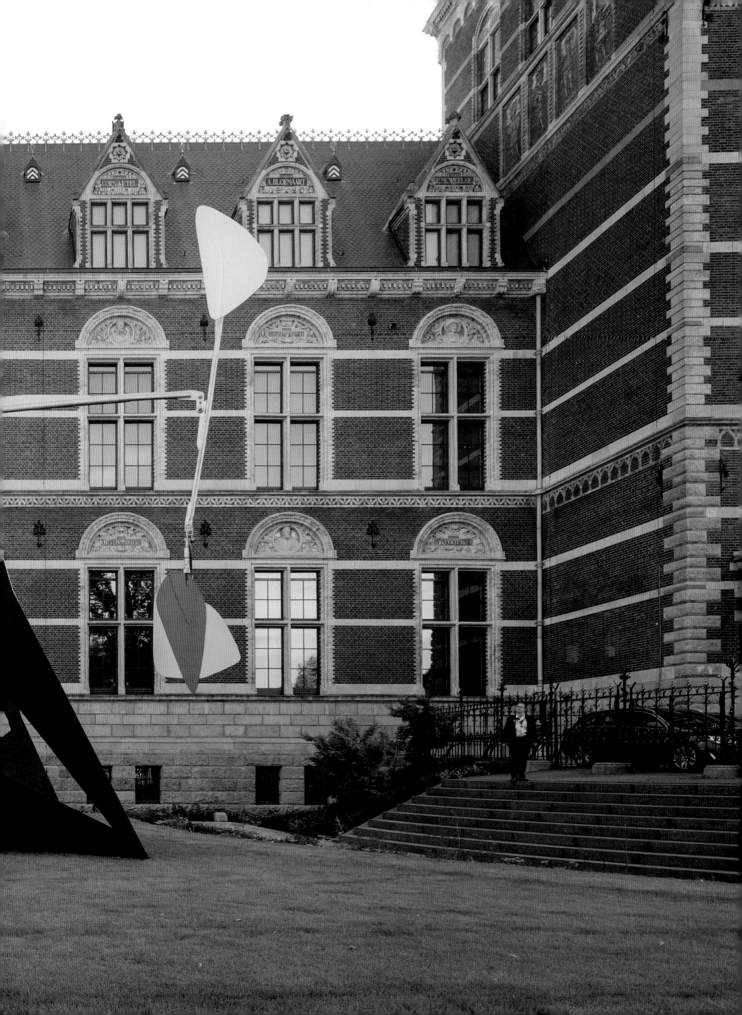

Tree preservation

Seven monumental trees remain. Near the entrance of the Philips Wing are two extremely tall Italian poplars. The two 15-metre bald cypress trees situated on the Stadhouderskadezijde side of the garden were stored away in a depot for ten years and have now been replanted. Tree specialists from Copijn took various measures to ensure the trees were cared for. The crown of the wing nut tree has been thinned out and its habitat improved. In this way, the condition of the can improve, which ensures longer-lasting and safer tree preservation.

375,000 historical tulip varieties have been planted at the base of the wing nut tree. In addition, the Keukenhof has its own area for cultivating tulip bulbs.

The garden also contains a series of ornaments in the form of historic building fragments such as old city gates from Groningen, Utrecht and Deventer.

What is new is the trend for natural-looking gardens. The enormous diversity in plants (early bloomers and late bloomers) in combination with different growth forms and colours in the form of grasses, ferns and bulbs is very different than in 1901. To achieve this, the designers have chosen an assortment of shrubs and perennials with a contemporary look that is at times dynamic and at times flamboyant. Where other garden objects need to dominate, it's serene. The choice between tranquillity or dynamism is inspired by Cuypers' style. Perennials and bulbs are planted between rows of boxwood. In other places too. Along the Museumstraat (Museum street) for example, borders are thriving with colourful plants and grasses.

• In composing this article, the author gratefully acknowledges the use of "Op Reis in the Rijkstuinen" ("Journey through the National Garden"), a folder created by Copijn, and of details imparted by landscape architect, project manager Sander Rombout from Copijn.

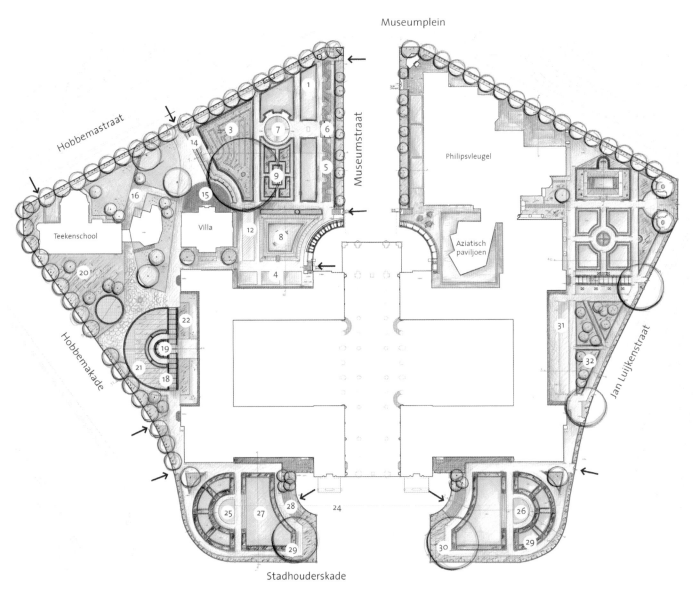

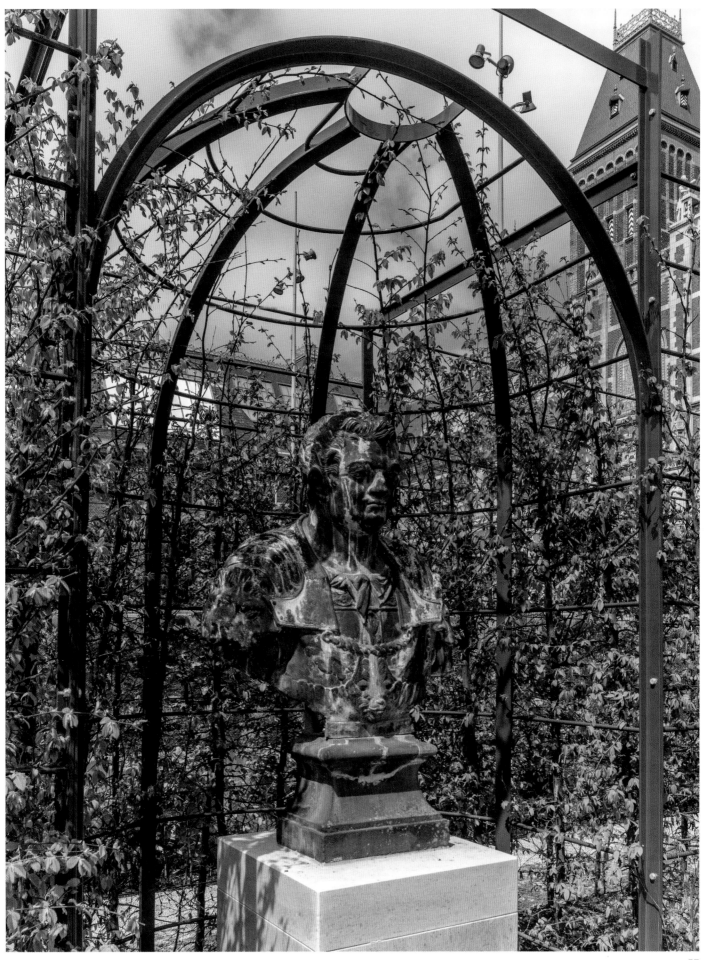

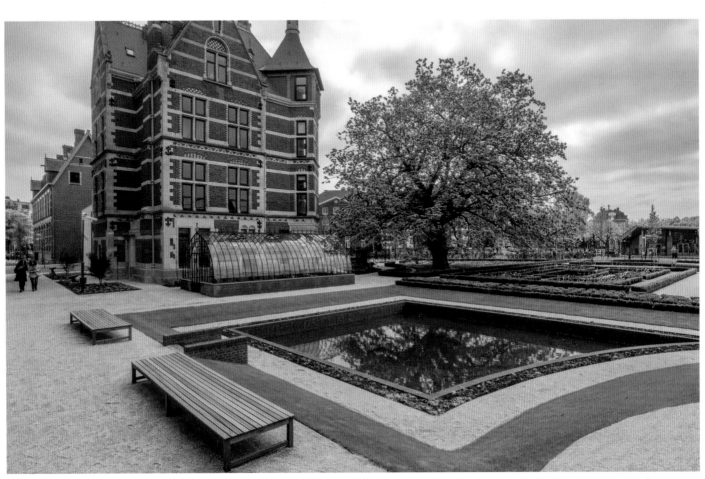

Floor plans & features

1 Main building

2 Studio building

3 Asian Pavilion

4 Entrance

5 Reception area

6 Philips Wing

7 Villa

8 Teekenschool (Drawing school)

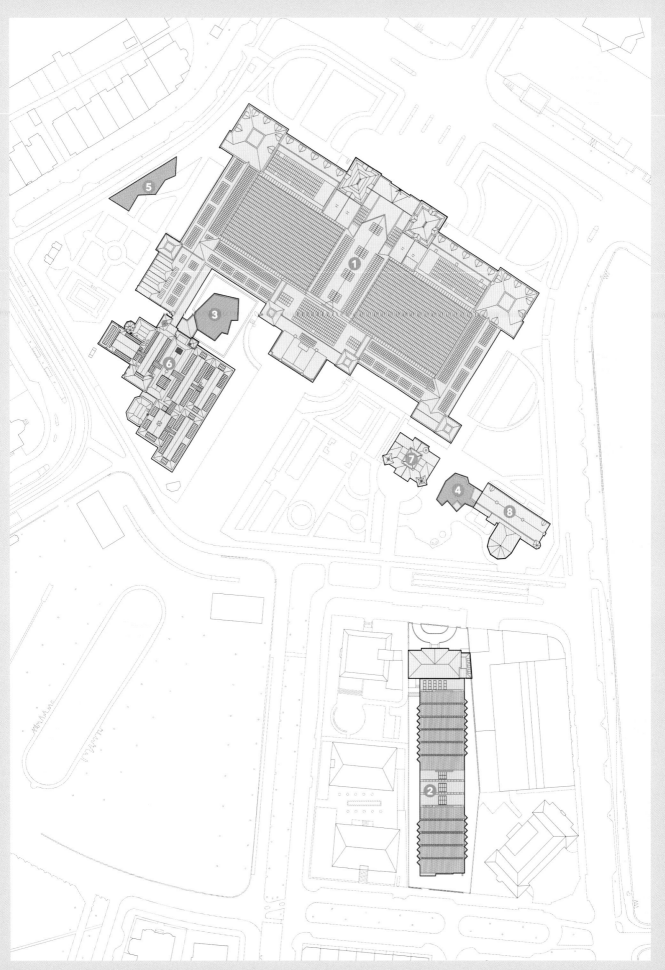

East-west façade

1 Reception area

2 Asian pavilion

3 Main building

4 Villa

5 Entrance

6 Teekenschool (Drawing school)

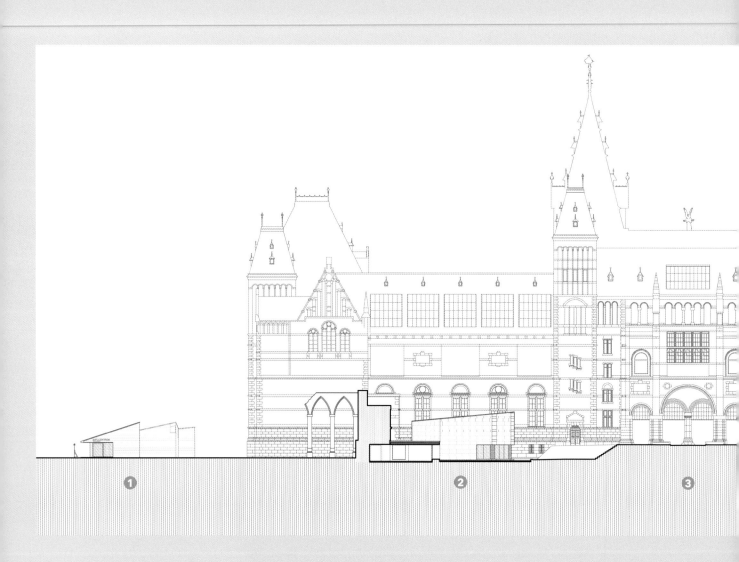

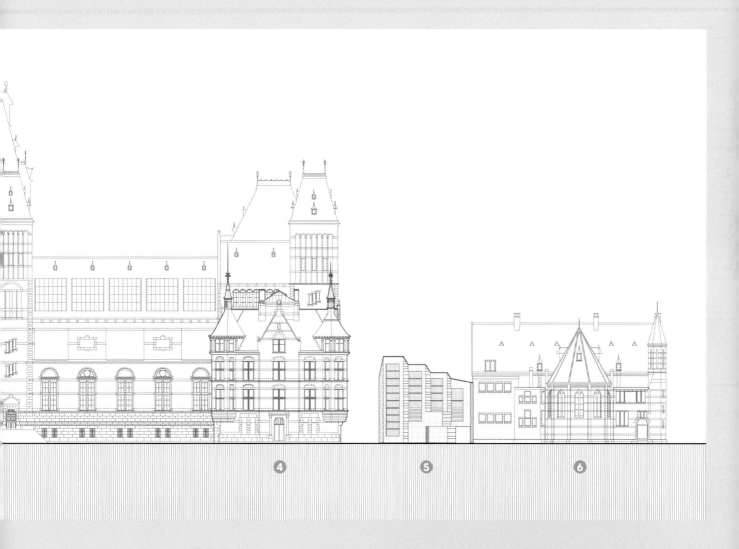

Basement level

1 Auditorium hall

2 Auditorium

3 Conference room

4 Museum shop

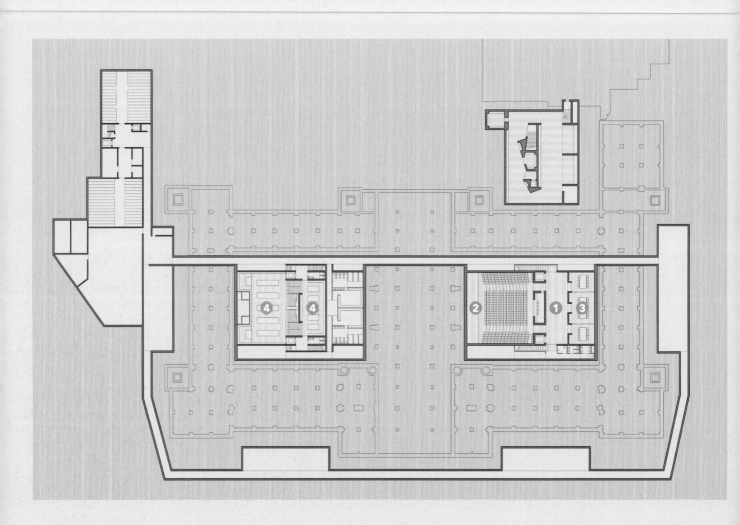

Ground floor level

1 Reception area

2 Ticket area

3 Cloakroom

4 Assembly area / entrance

5 Museum shop

6 Toilets

7 Exhibition gallery

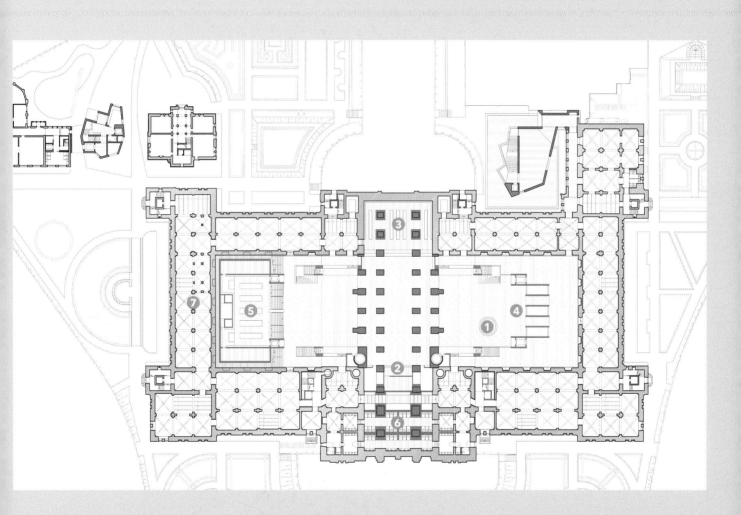

First floor

1 Museumstraat / underpass

2 Grand café

3 Cuypers' stairs

4 Cuypers' library

5 Exhibition gallery

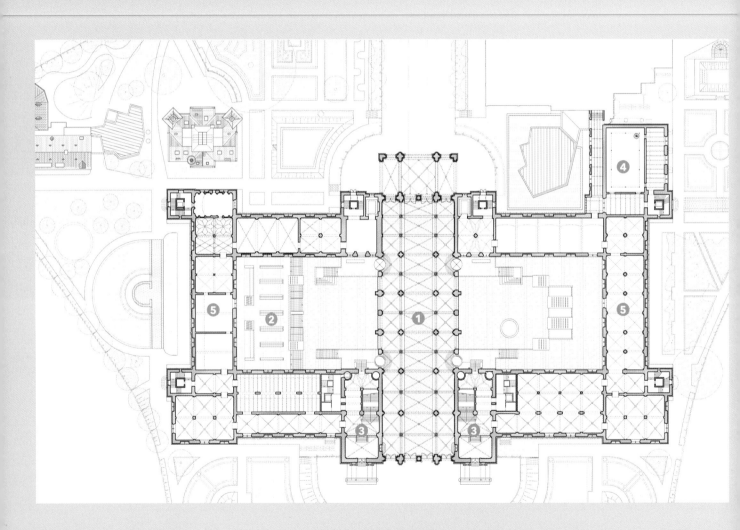

Second floor

1 Grand Hall

2 Gallery of Honour

3 Night Watch Gallery

4 Exhibition gallery

5 Chandelier

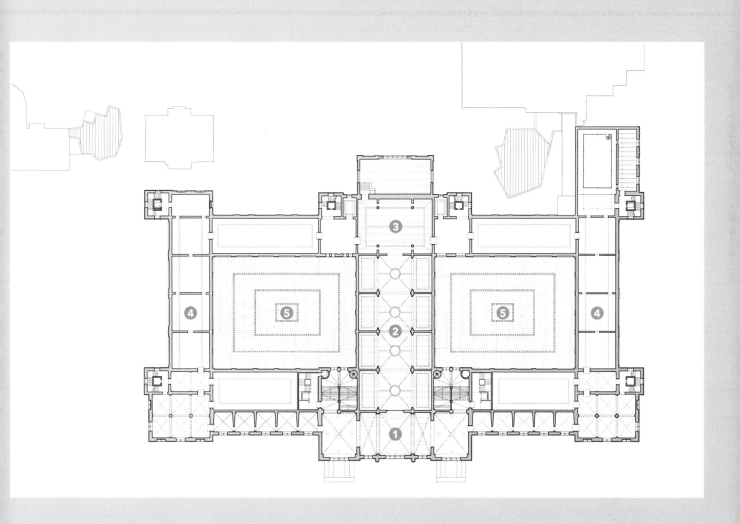

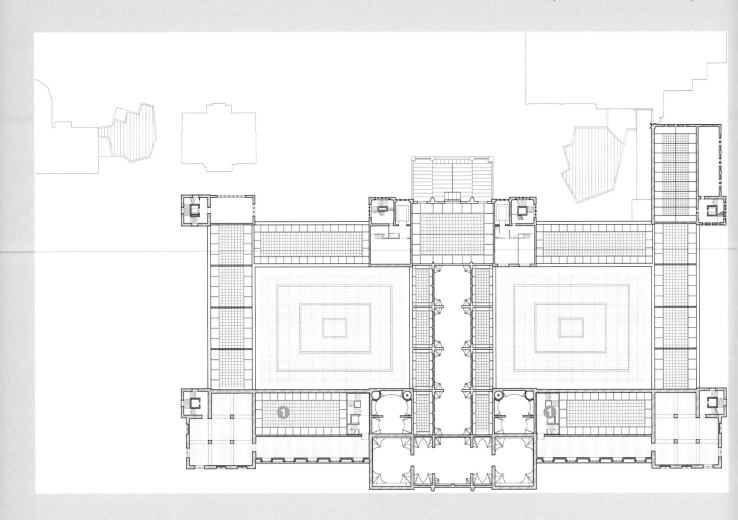

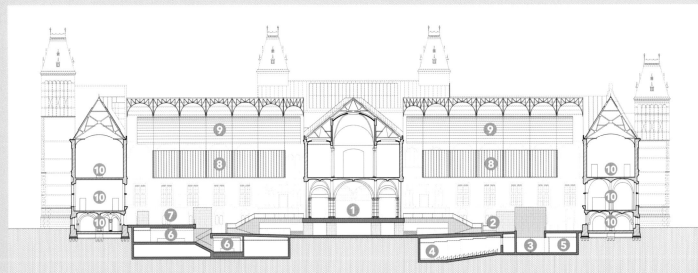

East-west cross-section

① Museumstraat / underpass

② Assembly area / entrance

③ Auditorium hall

④ Auditorium

⑤ Conference room

⑥ Museum shop

⑦ Grand café

⑧ Chandelier

⑨ Double window layer (Velum)

⑩ Exhibition space

East wing cross-section

① Museum shop

② Grand café

③ Chandelier

④ Double window layer (Velum)

⑤ Exhibition space

West wing cross-section

① Assembly area / entrance

② Auditorium

③ Chandelier

④ Double window layer (Velum)

⑤ Exhibition space

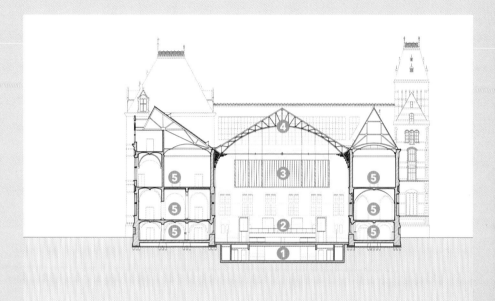

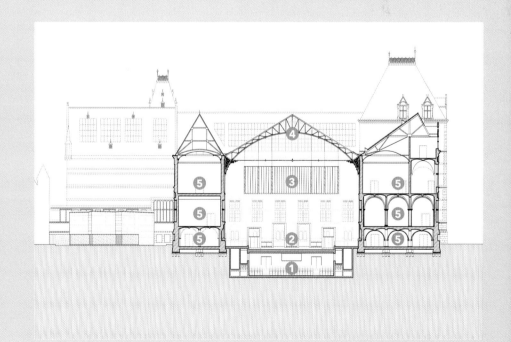

Original sketch drawn by Cuypers depicting
the exterior of the Rijksmuseum. (Collection
Cuypers House Museum Roermond)

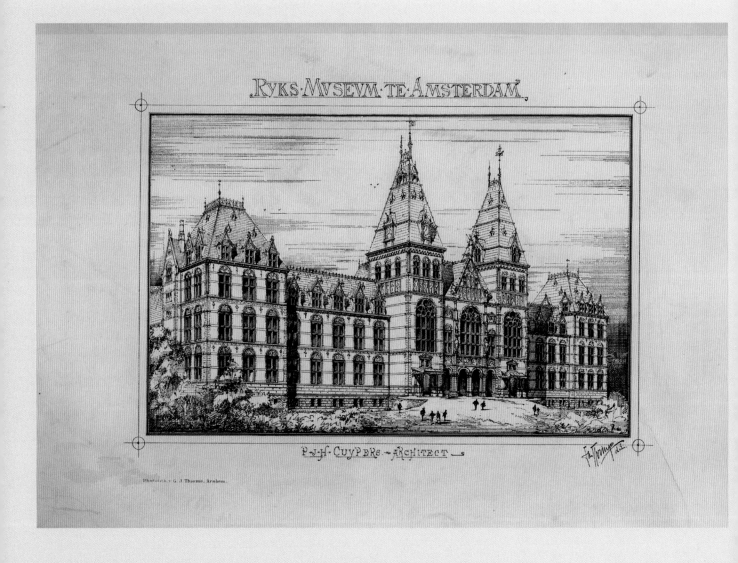

Secular cathedral

Pierre Cuypers has wrestled with his Rijksmuseum. For years the assignment, up to the construction, has defined the work in his studio. He is bone-tired at its opening in 1885: 'my mind has been dulled'. No wonder. The museum is one of his largest and most complicated achievements. During the construction, the style is constantly changed. Cuypers has had to step back from the multi-angular plan where the size of the auditoriums were only limited to the size of the building site. This was his ideal plan, where extensions were easily realised. When we see the renovated building – with its vivid silhouette and multiple towers, a miniature city – we can't imagine that this design is a compromise. We don't have that feeling at all when we experience the coherent design of aptly restored courtyards and auditoriums, and reconstructed colours in halls along the central axis.

Cuypers is ambitious and strives to reach the pinnacle. He doesn't make it easy for himself. With his friends – referendary (senior official) Arts and Science Victor de Stuers and the writer-philosopher Joseph Alberdingk Thijm – he diligently records every element of the monumental building down to the smallest detail. Draughtsmen, artists and artisans are the executors of the thoughts of the triumvirate, thus are not granted much freedom. Illustrious concepts, inspiration and creativity go hand in hand. Cuypers moulds them in his creative mind into something that it has never been. Fantasy, after all, is traditionally the exuberant combination of various elements, which give rise to a new creation.

A vivid historical piece

To the Catholic triumvirate, the museum represents a vivid, historical, three-dimensional piece not a treasure chest housing the past. It places art at the centre of life. It's not just a building, but a secular cathedral with rich ornamental elements. And as mediaeval cathedrals, the museum is a source of deep significance. In the nineteenth century, exuberant ornaments are commonplace in museums and public buildings. In the Rijksmuseum, meaning is etched

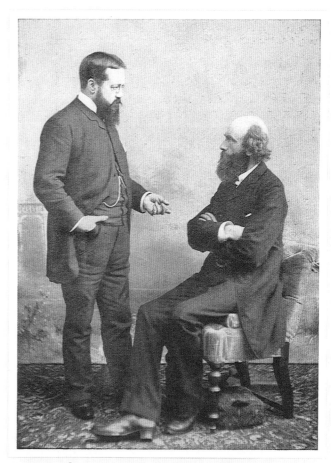

Jhr. Mr. V. de Stuers en Dr. P. J. H. Cuypers. (Omstreeks 1883).
(Uit de collectie K. J. L. Alberdingk Thijm).

As referendary (senior official) for the Arts, Victor de Stuers was responsible for the inception of the Rijksmuseum. He chose Pierre Cuypers to be its architect.

in the smallest detail. Not a single room escapes it. These splendid ornaments render art and history tangible and palpable to the visitors. At least, that's the intention. Artists and artisans go there to find their source of inspiration. To De Stuers and Cuypers, education and artistic enjoyment go hand in hand. Museums are laboratories, 'arsenals for artists and art industrialists'. The referendary wrote: They work like 'powerful planes upon the rough, unpolished bark of the public at large'. The rationale being that art leads to civilisation.

Cees Noteboom called the Rijkmuseum 'a treasure chest made of stone', in his novel *Rituelen* (*Rituals*). To Cuypers, De Stuers and Alberdingk Thijm the stone colossus is a representation of Heavenly Jerusalem, the idyllic celestial city descended to earth. It impresses through space, form and colour. It is an expressive building. It depicts the creative process and the experience of the public. Some reliefs, tableaus and images are instantly recognisable by their inscription.

With other expositions, visitors fail to comprehend the deeper meaning. After intensively restoring the entrance, Grand Hall, Gallery of Honour and Rembrandt Gallery, the wealth of images can again be experienced on the inside. These halls lie on the almost sacral central axis. Through the reconstructive painting of columns, walls and arches, it has regained its sacrosanct character. Cuypers' colours are by no means sombre and dark: they are bright hues of yellow ochre, red, blue, green and brown. Ornamental bands frame the paintings, making it clear we are entering a temple dedicated to art. The Grand Hall is not meant to be an exhibition space. It is a promenade with images created by contemporary artists. Shortly hereafter, we enter the Gallery of Honour and then the Rembrandt Gallery, an exalted chancel dedicated to art.

De Stuers and Alberdingk Thijm are extremely erudite. The referendary referred to such handbooks as *Metamorfosen* by Ovidius and *Iconologia* by Cesare Ripa, both revised by Karel van Mander. Thus, making it clear that the Rijksmuseum is not only an art, but also 'a historical and cultural museum'. Alberdingk Thijm supports these ideas by writing poetry and texts based on Catholic doctrines, which are incorporated into the ornaments. Furthermore, he couples the presentations with each other as in a mediaeval cathedral. He's responsible for the construction of the Grand Hall. They introduce art and history from our fatherland 'in an intelligible manner' envisioned as 'a harmonious whole', derived from the public unity.

Paintings and ornaments
Cuypers is responsible for the framework: the stonework, frames and ornamental bands , as well as the vines and stars on the arches. He utilised the chromatics of his great exemplar, the French restoration architect Eugène Viollet-le-Duc, and painted the walls, arches and pillars as a coherent whole. Viollet-le-Duc writes: 'decorative art expands or diminishes a building, makes it bright or sombre, falsifies the proportions or makes them count; distances or enhances, keeps pleasantly entertained or bores, divides or brings together, conceals faults or exaggerates them. It's a goddess, who is good and evil, but never indifferent'. Cuypers uses a warm, saturated colour range consisting of yellow, red and blue and the secondary colours orange, green and purple that produce a harmonious consistency. Furthermore, he treats the background as flat. The contours have tight, black lines and depth and illusionistic perspective are absent. Constructive elements like columns, frames and arches receive extra emphasis through patterned 'basket weave bond' brickwork – and vines. In this way, the colours influence the function of the room. The flat walls are dissected by horizontal and vertical bands, within which the paintings are hung.

The Austrian history painter Georg Sturm (Vienna 1855-Wageningen 1923), who had been appointed by Cuypers as a teacher at the Rijksschool voor Kunstnijverheid in Amsterdam, is responsible for the figurative paintings. Cuypers may have met him in 1877

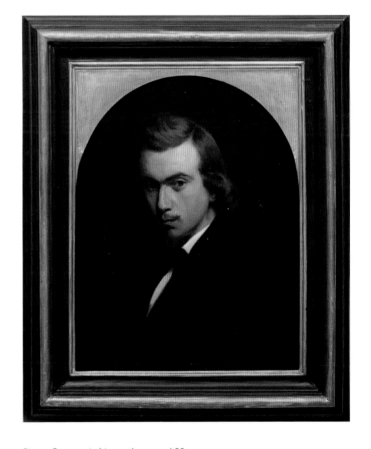

Pierre Cuypers in his youth, around 22 years old, 1849. Portrait is painted with oil paint on linen by Polydore Beaufaux. Dimensions 91.5 x 75.5 cm (Collection Cuypers House Museum Roermond).

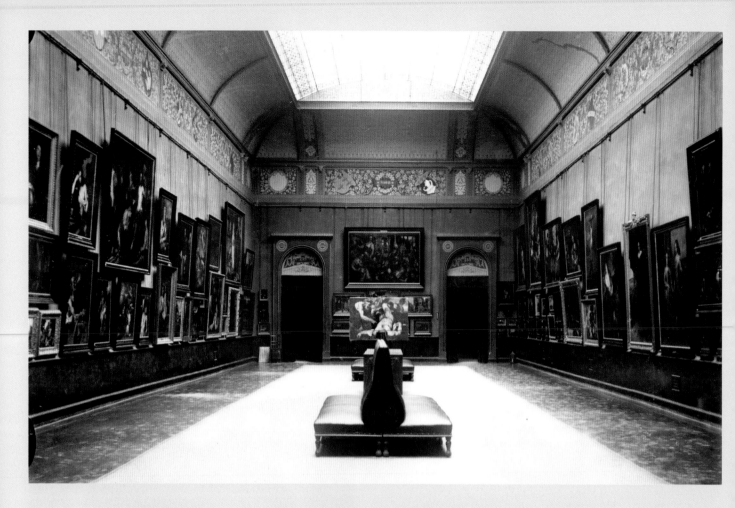

in Vienna during a state museum trip. Sturm comes to the Netherlands and designs the ornamentation for the Royal Waiting Room at Amsterdam Central Station for Cuypers, as well as the paintings in the state rooms in the Provincial Houses in Zwolle and Assen. In the museum he complies with the suggestions dictated by De Stuers. It is most likely that Cuypers had discussed the general outline of the compositions and left Sturm to sort out the final details. His paintings had to seamlessly blend in with the architecturally designed frames, much like the murals. Sturm also uses bright colours, flat backgrounds and dark outlines. Depth and illusionistic perspective are absent. The figures are arranged compactly next to each other. They are given more expressive power by well-structured outlines. They often have a symmetrical composition and are created on linen, sometimes in colour and sometimes in monochromatic shades of grey. The paintings were removed and fortunately spared when the halls were dismantled quite soon after Cuypers' death. It is the reason the increasingly whiter looking halls after 1921 could be returned to their former colourful splendour.

Typical Dutch characteristics and virtues
The Grand Hall is a space for parties and receptions, much like the large Burgerzaal (Citizen's Hall), designed by Jacob van Campen, in the former Town Hall on the Dam. The entire world is depicted here, as in Van Campen's Citizen's Hall, all 'human life and ideologies'. De Stuers describes how the floor signifies the physical aspect, the walls and windows the social aspect and the arched zone the intellectual aspect. The physical aspect is completely defined in the fully reconstructed terrazzo floor with its mosaic. Here we observe the Alpha and Omega – the beginning and the end of everything – the zodiac, the Four Rivers of Eden, the sun and the moon, the four elements and the times of day. The windows and walls symbolise the social aspect. On the north side, stained-glass windows from W. J. Dixon feature visualisations from architecture, sculpture, painting, philosophy, theology, poetry and music. Finally, the arched zone characterises the intellectual aspect, with its visual and auditory arts.

Sturm created large idealising paintings here, with typical Dutch characteristics and virtues. Floors, stained glass and paintings make the Grand Hall a *Gesamtkunstwerk*. Here, all the arts come together with the purpose of teaching virtue. The east wall propagates the love of art with the use of allegories from sculpture, architecture and painting. We see Bernulphus as the developer and Jacob van Campen, the architect behind the extremely admired Town Hall on the Dam. The west wall portrays science and features allegories from geometry, astronomy and mechanics. Amongst them, history showing Charlemagne (Charles the Great) and technology depicting Christiaan Huygens, the inventor of the pendulum clock. The broad south wall represents faith, hope and love. Sturm painted a series of allegories here with illustrative scenes beneath it. In this way, he portrays, for example, in the Jan van Schaffelaar presentation, the selfless love of a man who sacrificed

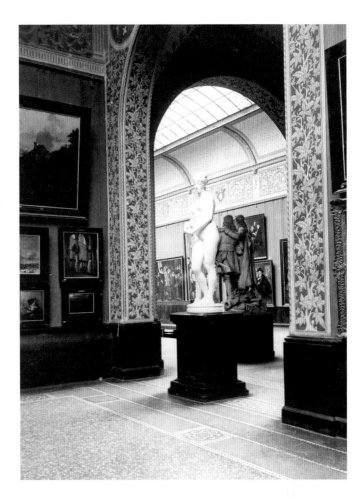

Rijksmuseum before renovation and restoration.

Grand Hall and Gallery of Honour before
renovation and restoration.

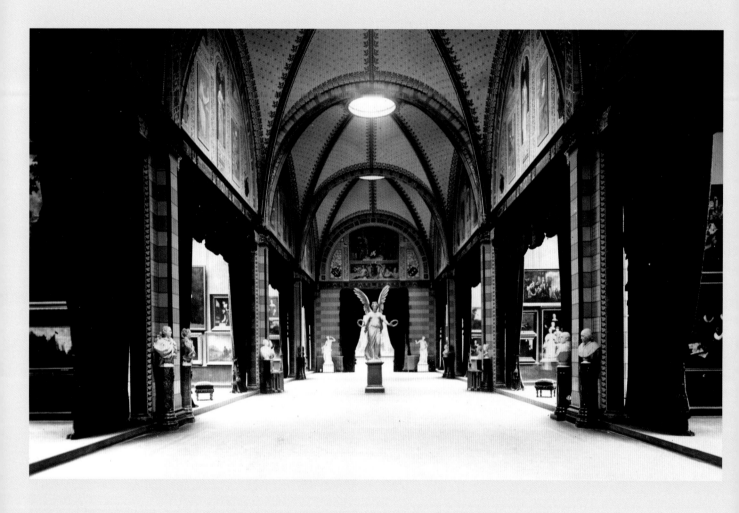

himself during the Hoekse en Kabeljauwse twisten (Hook and Cod wars) by jumping from a church tower to put an end to a siege. Under the presentation depicting patriotism we see Claudius Civilis' uprising against Roman occupation. A contribution from the Provinces to the arts is noticeable in the Gallery of Honour where there are allegorical female figures, coats of arms and craftsmen. The great masterpieces of our Golden Age hung here. The Rembrandt Gallery, the heart of the museum, is dedicated to Rembrandt, the bringer of light. The Night Watch hangs there, illuminated from above. The arch is painted with and supported by caryatids, who personify the light bringer's motif and are dedicated to the morning, day, evening and night.

In the museum, the triumvirate show their great erudition: classical, mediaeval, humanistic and 'Ancient Dutch' motifs are linked with each other in order to show the past as a mirror of modern art. In this ode, they make use of what Alberdingk Thijm describes as the fertility and elasticity of the Christian iconographic system. The three Catholic friends experience aesthetic enjoyment and associative mind games when designing and implementing the work. The museum possesses the uniformity and harmony of Cuypers' church interiors. An interconnected architectural artwork that is only fully decipherable for a small group of initiated. Cuypers and Alberdingk Thijm are convinced that the Rijksmuseum is on a par with such illustrious predecessors as the Greek Parthenon and the old Town Hall built by Jacob van Campen. This is where Cuypers, De Stuers and Alberdingk Thijm have played with time. They made use of elements from the past to create a new and original concept. A secular cathedral that, in their eyes, is a source of inspiration for artists, craftsmen and art lovers. Due to its restoration and reconstruction of the paintings, the Rijksmuseum is once again an expressive building. We now appreciate it as a museum piece and an atmospheric shell for a world-renowned art collection.

Wies van Leeuwen

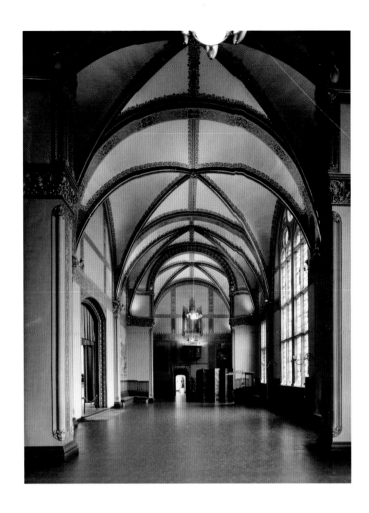

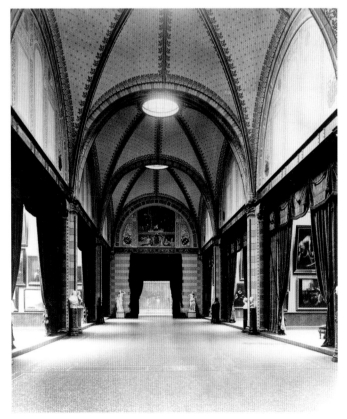

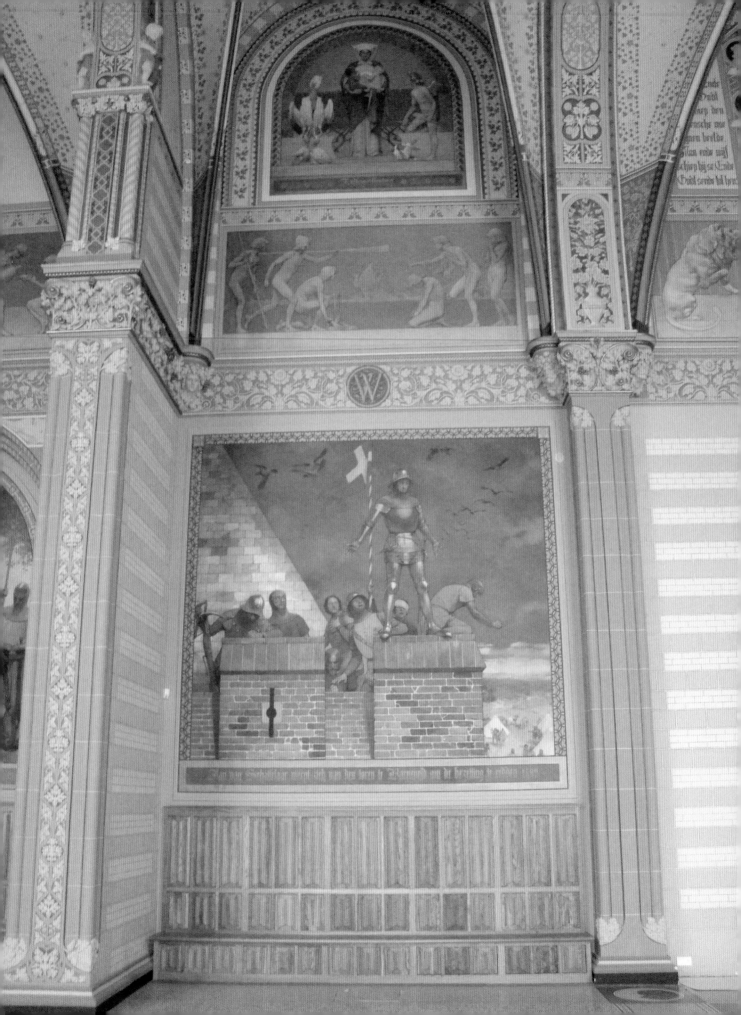

Reconstruction Cuypers' design.

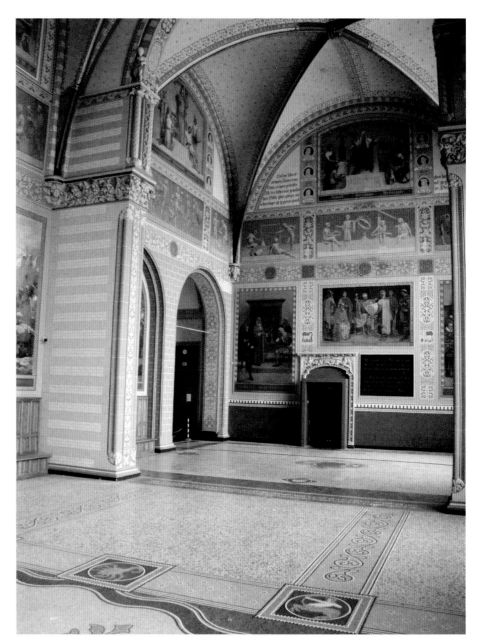

Voorhal met doeken van Georg Sturm met daar-
op Jan van Schaffelaar, held uit de Nederlandse
geschiedenis, en daarboven de Zelfopoffering
verbeeld.

Eregalerij met doeken van Georg Sturm.
Provincie van Overijssel met ambacht
Kleinschilderkunst, en schilderingen in de
Voorhal met onder andere de presentatie
van het ontwerp van het Paleis op de Dam.

Ornaments restored to former glory

Original ornaments from architect Pierre Cuypers have been reinstated in a number of places in the new Rijksmuseum. The Grand Hall is the only hall where the ceiling and the walls have been most fully reconstructed, based on its nineteenth century design. The rich ornaments were not exclusively applied as decoration in that time. Everything you see before you in the Grand Hall has a symbolic meaning. The ceilings and arches represent the 'spiritual world', the walls signify our patriotic history and the floor is covered with symbols, texts and figures. The entire room is complemented with beautiful stained-glass windows. Restoration and reconstruction of the arches and walls were carried out by the Stichting Restauratie Atelier Limburg (Foundation Restoration Studio Limburg) (SRAL) under the supervision of its former director Anne van Grevenstein.

Since its opening in 1885, the look of the Rijksmuseum has remained virtually unchanged. The interior, on the other hand, has become 'silted up' over the years. Light and air have been drained from the museum as a result of sealing both courtyards.
Under the motto 'Continue with Cuypers', two hundred experts, restorers and craftsmen have worked since 2001 to restore the lucid layout of Cuypers' original design. Amongst which Van Grevenstein's interdisciplinary team who restored the monumental ornaments in the Grand Hall, Gallery of Honour, Night Watch Gallery, Cuypers Library, the former entrance halls and in the two stairwells.

Colour and motifs
At first, this process didn't run smoothly. In the initial phase (2001) the focus had been, amongst other things, on gathering as much information as possible on colour and motifs from around Cuypers' time. Moreover, during visiting hours, stratigraphic research was being carried out in various parts of the complex to ensure thorough analysis of the coats of paint. This occurred behind the scenes as well as above the lowered ceilings, which were being examined for traces of original ornamentation. With just a magnifying glass and a scalpel, samples of paint were scraped from various areas in order to obtain a clearer picture of colour and motif. In addition, the samples were examined under a microscope to determine the paint's composition (for example the type of binder and pigment used). This aided in matching modern paint hues with the original colour palette.

These activities coincided with archival research. Old specifications from Cuypers were analysed, although the black and white photos depicting the initial decor as it once was, long before it was whitewashed, were of particular interest.

Dictates of society
The Rijksmuseum has been constantly modified since its establishment in 1885. This was attributed to the demands of the time – an increase in demand for exhibition space – but also to the dictates of society. At the time, it was thought that artworks would be better appreciated in crisp, white surroundings. One of the founding directors, Schmidt Degener, stated: 'I have tempered the excessive ornamentation.' In the course of the twentieth century it went from bad to worse, and at the end of the last century the original structure and ornamentation had all but disappeared.

Reconstruction
At the start of this project it was unclear whether or not (in the opinion of some) the colourful hues from the original design should be reinstated. Discussions ensued concerning the ornamentation on the interior of the Rijksmuseum: Is it attractive? Is it not too colourful? Would it distract from the artwork on display? Anne van Grevenstein attempted to reach a consensus by researching the possibility of restoring any still remaining ornaments. According to Anne, the Rijksmuseum is a *Gesamtkunstwerk*. That was why it seemed worthwhile to pursue the possibility of reconstructing the concept of Cuypers' ornaments. This method was an analytical and logical process for Anne.

Allegories of human virtue are depicted in the Grand Hall. As an example, Georg Sturm has again chosen to represent Self-sacrifice, this time in the form of a woman simultaneously breastfeeding one black and one white child.

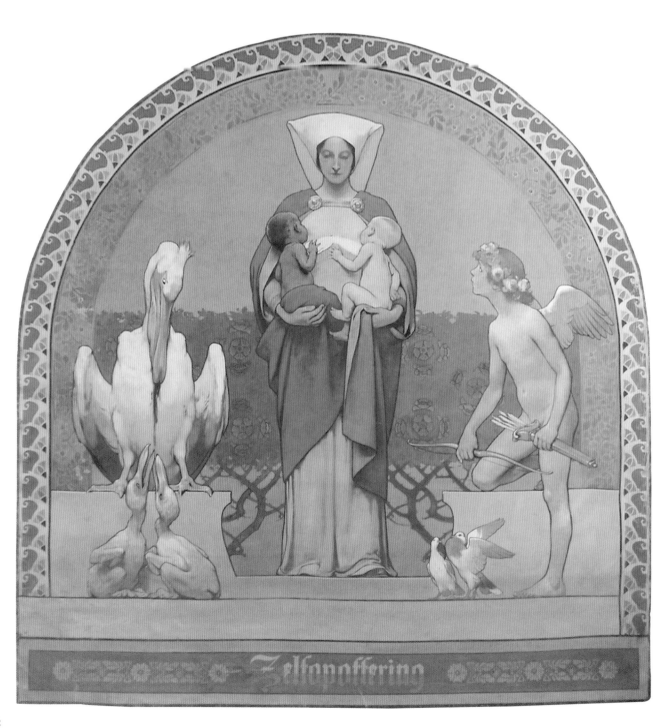

Zelfopoffering

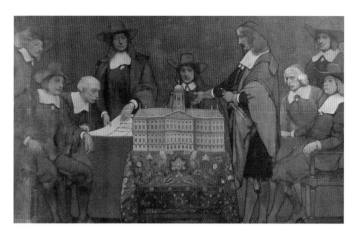

She did, however, wonder whether or not the previous Board of Directors could live with this method. After all, it wasn't something that could be controlled from the boardroom. 'I wanted to reach agreements, but as objectively as possible through empirical research, on what the best solution would be to achieve an optimal result. To do this, I involved as many of the interested parties as possible, including the museum staff, the public, both architects, the restoration architect, the District Council, the Monumentenzorg (National Trust) and the Cuypers Society.' It concerned an interdisciplinary study; an intensive cooperation between the architects and the restoration architect, but also between the people who researched the history of the construction and delved into the archives. The real breakthrough came with the discovery of an original, undamaged painting that was hidden behind a bookcase in the library.

Georg Sturm
After the initial research results, Van Grevenstein had fully reconstructed a small corner of wall in the Grand Hall. 'We reconstructed on a small scale whereby the painting's *trompe l'oeil* effect became clear: the painted cornice that served to connect the sculpted capitals had re-emerged. One of the magnificent painted wall canvases by Georg Sturm – Austrian-Dutch history painter (1855-1923) – was returned to its original position with around it a reconstruction of ornamental paintwork,' Van Grevenstein said. This first step meant that the potential of the restored Grand Hall could be envisaged in its entirety. A large part of the walls in the Grand Hall are already covered with these canvases painted by Sturm.
It's a unique collection of up to 70 canvases of various dimensions, restored and replaced by the SRAL. Of these canvases, 38 are part of the Grand Hall's decorative programme and 32 belong in the Gallery of Honour, of which there are a couple with dimensions measuring 4 x 4 metres. These were found rolled up in the storage room. The canvases had remained reasonably authentic even though they had sustained some damage – varying from moisture

damage to large creases around the edges. The paintings represent the traditional crafts, but also abstract allegories and virtues. 'All parties have kept a close eye on this reconstruction. That way every one could see for themselves that the paintings are not only colourful, but that they also serve a purpose within the architecture. An essential link exists between the architecture and the painted ornaments. Fortunately, the architects, museum Board of Directors and other involved persons considered this an excellent solution. In the Grand Hall, the history of the Netherlands is told with great pride through Sturm's canvases, and there are representations of the virtues which have made the Netherlands what it is today,' Van Grevenstein says.

Application of old techniques
In some places, the original ornamentation had been completely destroyed as a result of hewing through the layers of plaster. Elsewhere, Cuypers' colours had simply disappeared beneath layers of white paint. Unfortunately, it seemed getting to it would not be possible without seriously damaging the original historical paint texture. 'That's why we chose reconstruction,' Van Grevenstein explains. Certain areas in different rooms, which had escaped being painted over now provided useful information about the templates used and the detailed application, but mainly about the colour composition itself, which had aged naturally. This aspect was of elementary importance with regard to choosing the colours for the reconstruction, because this natural aging could be included in the restoration work. 'Therefore, we didn't completely return to the original state, but reconstructed the ornaments with modern materials. It would be remiss of me not to mention that our workers Nico van der Woude, Claudia Junge and Anne Rupert played a crucial part in this process as well as in the preliminary research.'

On one of the larger canvases in the Grand Hall Willibrordus preaches Christianity before a gathering of Friesians.

Cuypers employed craftsmen who were able to reproduce his designs. 'And so did we.'
72 students from the SintLucas in Boxtel – studying at Intermediate Vocational Education level and majoring in Design & Arts and Crafts – worked for three months on this project. Each time a new consignment of students arrived, they received a two-week long workshop on nineteenth century painting techniques. After that, they were put to work under supervision of a restorer from SRAL. Moreover, they applied old techniques using hand cut templates and spolvero (soot). The detailing of which were completely painted freehand. 'The evolvement of skill in that area was in the hands of our team, which consisted of a permanent group of restorers from SRAL and a new rotation of students every three months,' Van Grevenstein says.
'At the end of the internship a number of students successfully passed an aptitude test for craftsman, (the Master Assessment). Over the course of the first three years family and friends could see and admire just what had been achieved.

The mixing of Cuypers' colour palette was done on site by restorers from SRAL, and the close collaboration with Sikkens/AkzoNobel has been a particularly positive one. With this information, they were able to reproduce Cuypers' colours using a synthetic yet durable paint.
The retouching of the colours was applied without affecting the existing layers. The reconstruction is reversible and therefore provides the ideal protection for the authentic material. The finished result is a beautiful, visually colourful concept carried out by persons with varying disciplines.

It's a repeat of the history of the Rijksmuseum, as it were. If you look at everything that has been achieved, there's an overwhelming feeling that it has never been anything else,' Anne van Grevenstein concludes.

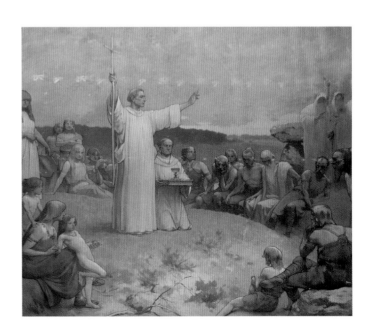

Life is short, but art is forever. Sculpture,
Architecture and Art.

Justice and Right.

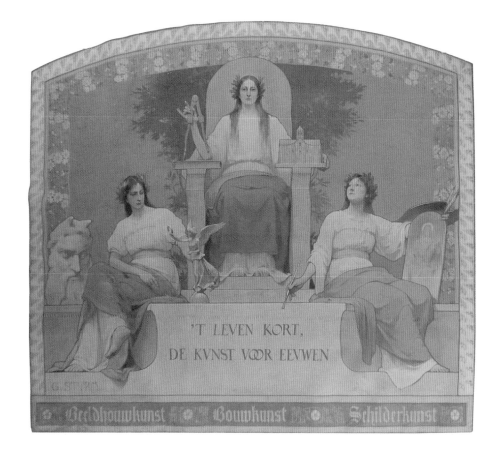

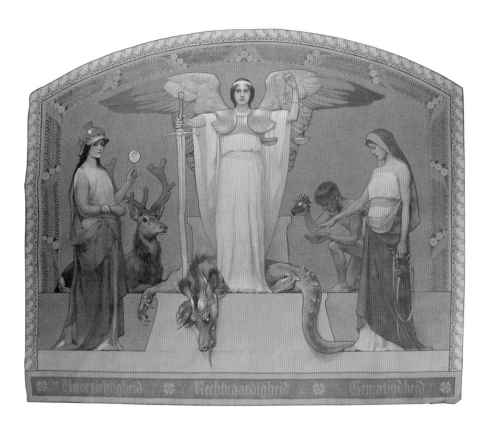

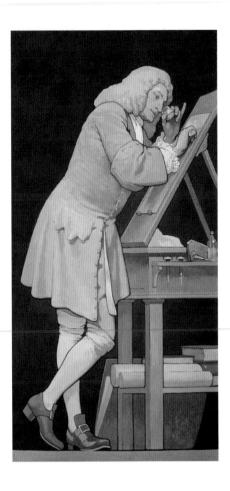

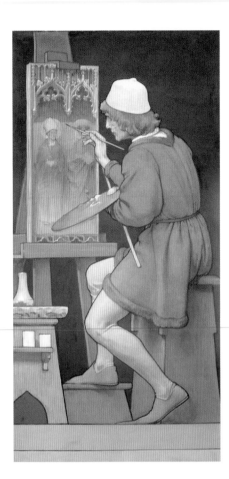

Engraver with magnifying glass.

Painter.

Brassfounder with file. A craftsman who produces cast ware from brass.

Architect with compass.

Carpenter at workbench.

Metalsmith.

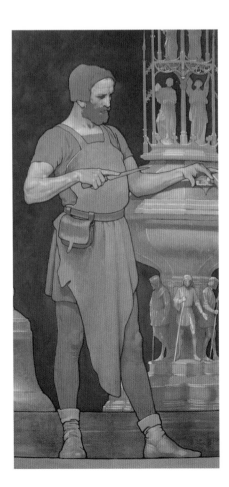

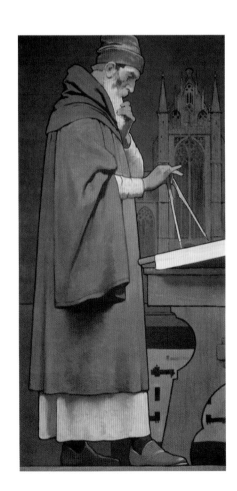

Georg Sturm rediscovered

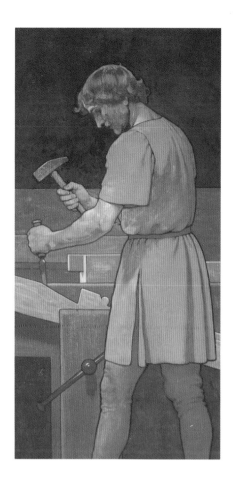

From the beginning, architect Pierre Cuypers perceived his design for the Rijksmuseum as a Gesamtkunstwerk. He'd designed the entire building from one perspective. The exterior and the interior formed a whole and every ornament served a purpose.

The Austrian-Dutch history painter Georg Sturm (1855-1923) was friends with Cuypers. At Cuypers' request, he produced 70 wall canvases that ultimately became an integral part of Cuypers' Gesamtkunstwerk. They were restored between 2007 and 2012 and preserved by the Stichting Restauratie Atelier Limburg (Foundation Restoration Studio Limburg) (SRAL).

On behalf of the SRAL, restorers Jos van Och and Bianca van Velzen describe this exceptionally creative project.

About thirty years after the official opening of the Rijksmuseum in 1885, the first paintings were removed from the wall.

In the course of 2005, 70 canvases by Georg Sturm were rediscovered in the basement depot of the Rijksmuseum. At the time it wasn't clear whether or not they would be reinstated in the new Rijksmuseum. It was feared that the presentations would be too moralising and therefore unsuitable for the Grand Hall and the Gallery of Honour. The canvases belonged inside the building and weren't a part of the collection. The Government Buildings Agency gave the SRAL the task of restoring the canvases, its main aim being to reinstate them in the new Rijksmuseum, embedded within Cuypers' wall of ornaments. The SRAL restored the canvases under enormous interest of the museum-going public at its studio in the Bonnefantenmuseum in Maastricht.

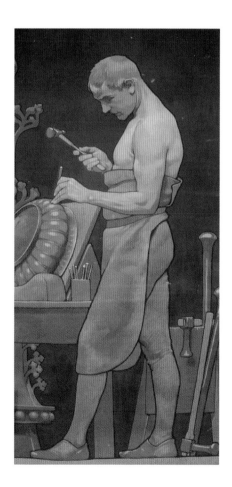

Fragile material

'It was apparent that the canvases had been stored unframed for a long time, divided into six rolls and lying in a stuffy room, as a result of which they'd started to distort and deform. Most damage resulted from dismantling the wall mountings and from the fact that the canvases had

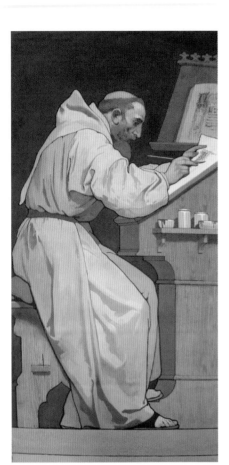

Monk intended to make a book more beautiful.

Nun with embroidery.

been rolled up with the paint layer on the inside. Because the canvases weren't stretched, they're more fragile. They can crack, whereby the paint starts to peel off fairly quickly,' restorer Jos van Och explains.

All the canvases were rolled out, photographed and documented. After that, they were measured one by one. They were never mounted on a stretcher frame, but directly mounted onto the walls. We're talking about large dimensions: two rectangular canvases measuring 4 x 4.10 metres and ten canvases with a rounded top measuring 4 x 3.83 metres.

The damage isn't the same for all the paintings. The restorers had consulted with experts from the Rijksmuseum about the procedures.

The restorers took the most damaged canvas and used this as their test sample. For this purpose they prepared a plan for treatment.

Every painting requires its own condition- and management report. Interns and students have also worked on this intensive inventory.

Almost all the canvases had to be flattened. This meant that all irregularities had to be minimised. This occurred by means of a moisture treatment method whereby canvases are temporarily stretched.

It was also important to research how the canvases could be cleaned. Furthermore, it seemed on closer inspection that the collection was made up of two different ensembles: the canvases from the Gallery of Honour seemed to have been painted with a different type of medium than those from the Grand Hall. Therefore, a separate treatment plan had to be devised. Within each ensemble, however, an equivalent treatment had to be devised. 'They had to receive equal treatment in order to prevent them from emerging as separate 'stamps' afterwards,' conservator Bianca van Velzen emphasises. A painstaking and lengthy process of filling and retouching followed.

Etcher.

Brick moulder, worker who works in a brick factory and prepares the clay or stone before they enter the kiln.

Furniture maker with gouge.

The faience painter.

Furniture maker with carpenter's plane.

Children caring for the sick.

Children at the cross.

Children in Roman armour.

Children and justice portrayed.

Oil paint without varnish

Research showed that the canvases in the Grand Hall were painted with oil paints and never varnished. All the images are painted very accurately and with swift brushstrokes. They are less pictorial than other canvases and Sturm outlined his figures and hardly gave thought to depth.

In the Gallery of Honour, the lighting is different and the paintings hang higher, resulting in a different experience by the viewer. Sturm worked here with casein paint with a high matt finish, in order not to allow disturbing light reflections to occur. Despite the fact that Sturm produced his paintings on canvas, they were meant to be murals. Cuypers and Sturm strove to integrate the stretched wall hangings as much as possible with the architecture and the painted ornaments. The colour scheme is an integral part of the whole effect. The paintings were realised in the years between 1882 and 1900 and represent amongst other things images of the traditional crafts, but also more abstract allegories and virtues.

Architecture

Allegories and human virtues are represented on the large canvases in the Grand Hall. On the largest canvas (4 x 4,20 metres) Willibrordus preaches Christianity before a gathering of Friesians.

Self-sacrifice is represented by a woman simultaneously breastfeeding one black and one white child, flanked by the Christian motif of a pelican feeding her young with blood from her own breast. This known fact is also depicted in late mediaeval art.

The elongated grisaille paintings are painted as classic stone relief by Sturm and his assistants. For this he used two colour variations, with the use of the colour ochre as its background.

In the Gallery of Honour the traditional crafts are represented, such as art, architecture, textile arts, goldsmithing, and engraving, depicting a different aspect of their profession or art form. For example, two engravers show the engraving to the left and the etchings on a copper plate to the right.

The miniaturist painters are represented by an artist who, according to late mediaeval tradition, paints his miniature into the frame, and by a monk who applies a miniature in a handwriting. Architecture is represented by a portrait of Cuypers.

Reinstating

As preparation for the definite reinstatement of the 70 canvases, the restorers hung two paintings in the Rijksmuseum on November 2011as a trial, to test the waters. In the months of April and May of 2012 all the canvases had been returned to their original places.

With the large scale restoration and renovation of the Rijksmuseum that began in 1999 it had been decided, under the motto 'Continue with Cuypers' to restore a part of Cuypers' Gesamtkunstwerk to its original state. This doesn't apply to the entire building. Only the most important halls in the main axis of the museum, such as the Grand Hall, the Gallery of Honour, the Rembrandt Gallery and two stairwells, have been decorated with original ornaments dating from 1880-1910. Georg Sturm's historicising wall canvases were a part of these halls. They took their original places in April/May 2012 in the new Rijksmuseum and are embedded within Cuypers' ornaments.

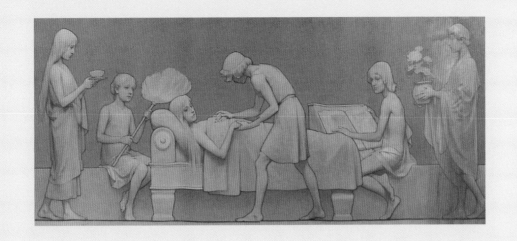

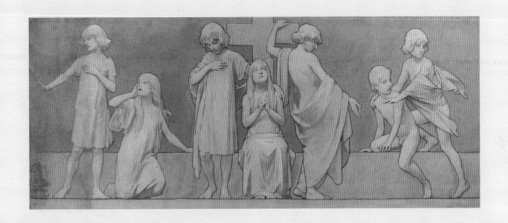

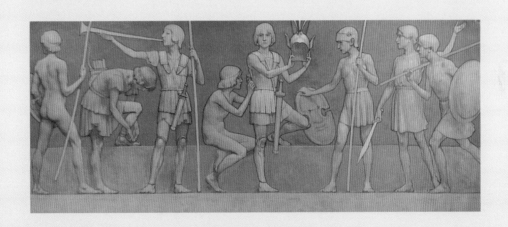

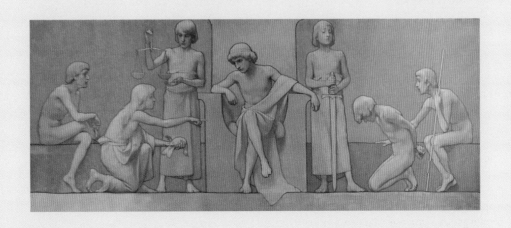

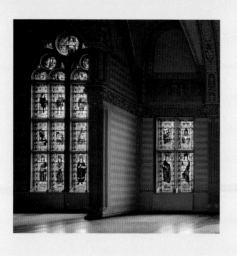
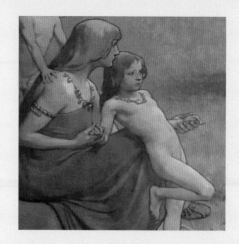
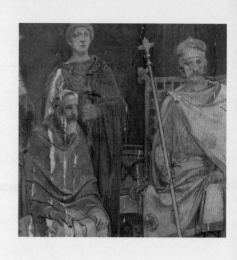

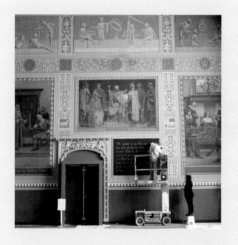
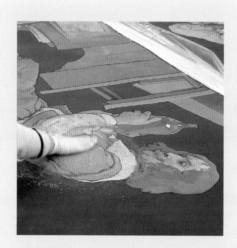
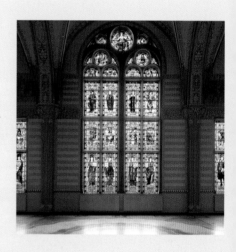

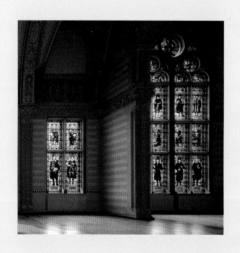

Cultural heritage

There are often numerous dilemmas associated with the restoration of a protected monument. Moreover, the terms *conservation*, *restoration* and *reconstruction* can be interpreted and applied in different ways. A grey area exists within the Monumentenzorg (National Trust) which allows house painters and decorators to work as subcontractors and become part of a project where historical and material knowledge are necessary. In 2001, the Rijksmuseum project 'Continue with Cuypers' correctly anticipated a vast need for occupational differentiation and interdisciplinary cooperation. It was shown that decorators could achieve excellent reconstructions of original nineteenth century concepts, based on historical and material research, once solely the domain of scientifically trained restorers. Those who speak of dilemmas within the Monumentenzorg (National Trust) understand that choices have to be made. Protection of the original concept, the wishes of the public, respect for the 'ravages of time' or the need for untouched beauty often stand diametrically opposed to each other. A creative, artistic chief architect and a restoration architect rarely have the same agenda. Ethical discussions can only lead to a coherent management plan if prior opinions are expressed by virtue of a thorough historical and material analysis. Only then can choices be made and their implications assessed. The fact that this unique opportunity presented itself in the project can only be called exceptional and, through joining forces, ten years of research, education, conservation and restoration have collaborated in extraordinary fashion. The multidisciplinary team ensured a constant flow and exchange of relevant information. Research was done on site, in the archives and in the laboratory: very different environments with their own language and background. An advisory committee followed the work on a regular basis and helped reach decisions on difficult choices.
De Rijksdienst Cultureel Erfgoed (The Cultural Heritage Agency of the Netherlands) and the Sikkens laboratory provided chemical analyses of the pigments. The Cuypers Archive and the Rijksmuseum archive proved to be a rich source of information on the initial creative process: old templates were preserved, but also letters and sketches made by Cuypers containing data on the colours and materials used at that time. Countless black and white photos depicting the initial decor long before it was whitewashed gave a unique insight into the form and flow of the ornaments. Students from the University of Amsterdam (MA course on Conservation and Restoration) incorporated it in their thesis and participated in the 'workshop on 19th century painting techniques' in which they received help on a practical level from their Intermediate Vocational peers from SintLucas in Boxtel. This completely non-hierarchical way of exchanging knowledge was perhaps the most amazing part of the project: together, ensuring the preservation of our cultural heritage by learning each other's language and work on site. Countless groups of students have shared in this experience and they will act as a bridge to the future in the preservation of these ornaments.

Without the preservation of authentic parts of Cuypers' ornaments, such as Georg Sturm's canvases or the stained-glass windows in the Grand Hall, the reconstruction of the ensemble would not have been possible. The line between fantasy and historically relevant reasoning is blurred and susceptible to misinterpretation. In the Rijksmuseum there is an overwhelming feeling that the ensemble has never been anything else. For the visitor, the new Rijksmuseum is history's living, rediscovered beauty.

Anne van Grevenstein

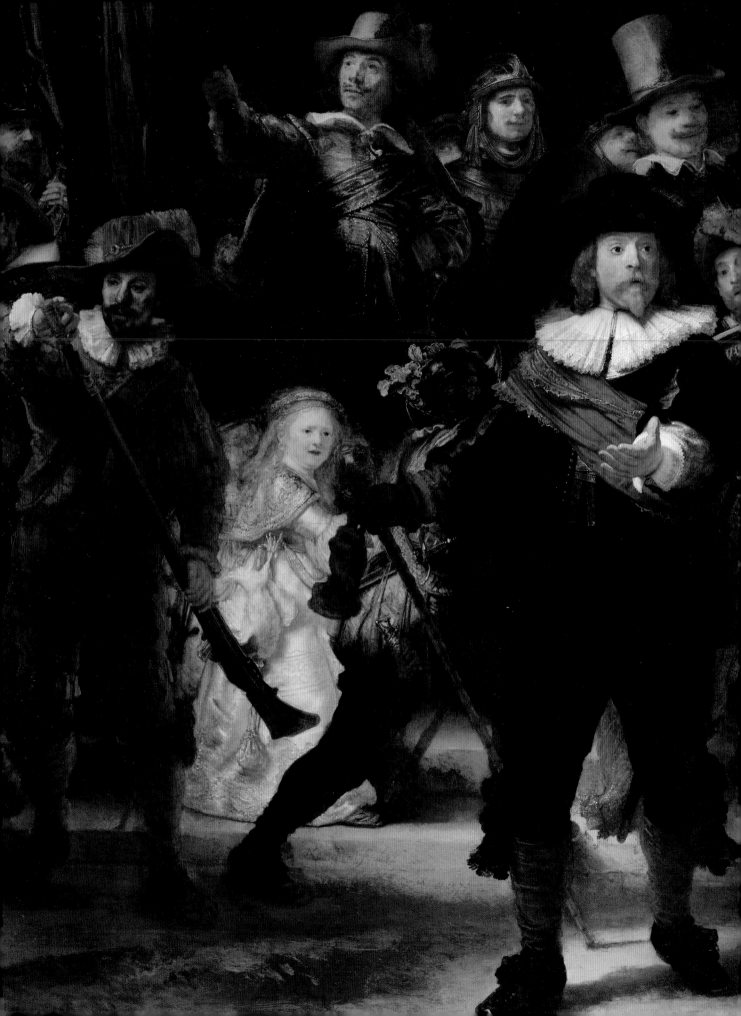

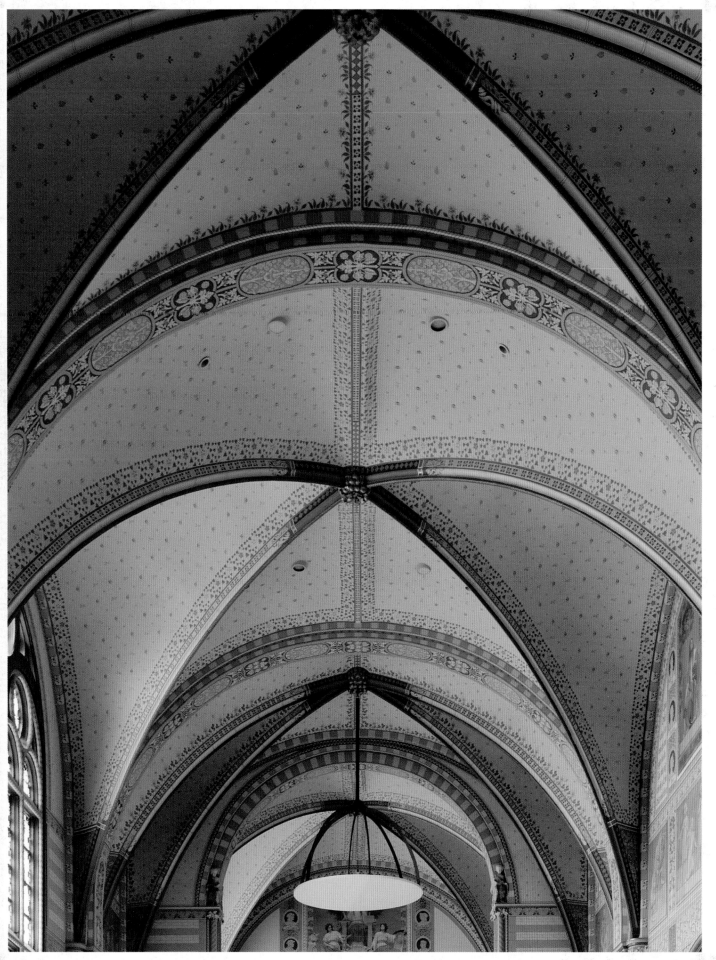

Colophon

RIJKS MUSEUM. The Building, Collection and Outdoor Gallery.

Compiled by
Cees W. de Jong, Naarden &
Patrick Spijkerman, Zoetermeer

Design and lay-out
Cees W. de Jong, VK Projects, Naarden
in collaboration with Asher Hazelaar, Puls, Ermelo

**With thanks to the following persons,
businesses and institutions**

Cruz y Ortiz arquitectos, Sevilla

Cruz y Ortiz arquitectos,
Muriel Huisman, Amsterdam

Cuypershuis, Roermond

Sander Rombout
Copijn Tuin- en Landschapsarchitecten, Utrecht

Peter Derks
Director of the New Rijks Museum

Frits van Dongen
Chief Government Buildings Architect

Anne van Grevestein
Emeritus Professor UvA

R. Hoppenbrouwer
Director Restauration Studio Limburg

Janine Hövelings
Museum Cuypershuis, Roermond

Wies van Leeuwen

Wim Pijbes
General Director of the Rijksmuseum

Ronald Tilleman, Rotterdam

Pedro Pegenaute, Pamplona

Rijksgebouwendienst,
Ministerie van Binnenlandse Zaken en
Koninkrijksrelaties, Den Haag

Atelier Rijksbouwmeester, Den Haag

Rijksmuseum, Amsterdam
John Lewis Marshall & Erik Smits

Sint Lucas Vormgeven & Ambacht
Opleiding restauratieschilder, Boxtel

Stichting Restauratie Atelier Limburg (SRAL),
Maastricht

Every effort has been taken to ensure that the names and addresses of the persons holding the rights to the footage provided for this publication have been correctly identified. Those who believe their rights in regard to the photographs and / or footage have been breached are advised to contact VK Projects in Naarden.

Images
Cruz y Ortiz arquitectos, Amsterdam
Floor plans & features on pages 60, 61, 62-63, 64, 65, 66, 67, 68, 69

Cuypershuis, Roermond
Images on pages 70, 71, 72, 73

Copijn Tuin- en Landschapsarchitecten
Images on pages 50-51, 52, 53, 54-55, 56, 57, 58, 59

Pedro Pegenaute, Pamplona
Images on pages 12, 14, 15, 16-17, 19, 20, 21, 22-23, 24-25

Rijksmuseum , Amsterdam
Images on pages 38, 39, 40, 41, 42, 43, 44, 45, 46-47, 48, 49

Stichting Restauratie Atelier Limburg (SRAL), Maastricht
Images on pages 78, 79, 80, 82, 83, 84, 85, 86, 87, 88, 89, 90, 91, 92

Ronald Tilleman, Rotterdam
Images on pages 30, 32-33, 34, 35

Printed by DZS Grafik, Ljubljana